W9-ATF-845

CARING
FOR
YOUR
ART

THIRD EDITION

CARING
FOR
YOUR

Jill Snyder

with illustrations by
Joseph Montague

"Using Computers to Help Care for Your Art"
by **Maria Reidelbach**

"Interviews with the Experts"
by **Ann Craddock Albano**

ALLWORTH PRESS, NEW YORK

Published by Allworth Press, an imprint of
Allworth Communications, Inc.,
10 East 23rd Street, New York, New York 10010

Book design by Douglas Design Associates, New York

Cover design by Derek Bacchus

Artwork © 1991 Joseph Montague, New York

"Using Computers to Help Care for Your Art" © 1996 Maria Reidelbach

"Interviews with the Experts" © 2001 Ann Craddock Albano

Library of Congress Catalog Number: 96-83243

ISBN: 1-58115-200-0

Printed in Canada

Dedication

To my family and to the memory of Lucy

Acknowledgements

This book could not have been written without the help of many professional friends and colleagues. Crucial assistance was extended along the way by my museum colleagues, Betsy Carpenter, Ani Gonzalez-Rivera, David Heald, Jane Rubin, and in particular Zuzu Estabrook, who read my drafts patiently and thoughtfully. Special thanks are due to Tony Moore, who as friend, colleague, and artist provided technical expertise and guidance. I am indebted to Ann Albano for her skillful contribution to this revised edition.

My real gratitude to Joseph Montague, who served as an inspiring collaborator as well as an able illustrator. I would like to acknowledge the presence of his many ideas now woven into my text. Finally, to Tad Crawford for his unwavering support and commitment to this project. I am deeply grateful for his flawless editing skills. Like a jeweler, he knows exactly where to cut and polish.

Table of Contents

List of Illustrations

1

The Importance of Caring for Your Art

> "No method nor discipline can supersede the necessity of being forever on the alert."
>
> *Walden, Henry David Thoreau*

This book provides simple and useful guidelines for the safekeeping of your artwork. While the book tends to single out and address the concerns of the artist in his or her studio, the information is useful for any person who must care for art. This includes the collector, the art dealer, and the legions of small cultural institutions which lack the assistance of in-house professional technicians to care for their art. *Caring for Your Art* reflects up-to-date methods culled from interviews with artists, conservators, preparators, and other art professionals.

Caring for Your Art proceeds from the general to the specific, from an overview of potential hazards in the environment to specific recommendations for proper storage, matting, framing, photographing, documenting, crating, and shipping of artwork. The concluding chapters on insurance and security supplement the discussion on preventive measures by addressing the issue of protection against damages which are outside of one's control, such as theft, flood, fire, and injury.

In outlining preventive care, emphasis is placed on what measures can be taken to avoid the damage and wear occurring through unnecessary exposure and improper handling of artwork. Keep in mind that what may be done to a work of art and the method by which it is handled may not have immediate consequences. The fruit of preventive care is in the longevity of the work and the relative stability of its material components. Achieving this goal may involve a process arrived at through a system of checks and balances. No two spaces are alike, nor are their environmental conditions. This book outlines basic methods which are flexible and can be adapted to the variables in the individual studio, display or storage facility.

Preventive care for art, like preventive health measures, needs constant vigilance and continual maintenance. We are all guilty of the desire to take shortcuts in maintaining our physical health — avoiding regular physical exams, eating too much of what is not good for us, skipping daily exercise regimes — under the assumption that a few nips and tucks here and there will not have long-term consequences. If we're lucky, we think, nothing serious will result from such peccadilloes. Then regret sets in, along with a reevaluation of habits. One of the goals of this book is to prevent a situation in which the damage to a work of art causes you to look back and say "If only I had done this." And this, most often, was just a simple preventive measure.

The Roots of Preservation

The importance of caring for art can be traced to the ancient roots of civilization. There, at the source, it is linked to the growth of civilization itself. For documentation or for spiritual transference, the

impulse to preserve objects was a natural extension of human's quest for survival. As early as 7000 B.C., the ancient Sumerians found that reeds could be used to etch language into clay tablets, and in so doing they began to record the world as they knew it. This fundamental discovery led to a shift from a society reliant on oral tradition to one which transferred information through written records. Not only did record keeping systems facilitate economic management, but they were also used to propagate the accomplishments of royalty. According to one Sumerian legend, Enmekar, the ruler of Uruk, had to drink foul water in the nether world because he had not left a written record of his victories for the instruction of future generations. So, with this simple discovery, war, birth, death, and property ownership were no longer the stuff only of legend or recollection, but could be preserved in concrete form for posterity.

Preservation was not related only to record keeping, but to the primal belief that spirit was transferred into matter. In many cultures relics are seen to be empowered with spiritual life and act as surrogates for eternalizing our own more transient human existence. Nowhere is this more evident than in the ancient Egyptian culture, with its magnificent and elaborate rituals devoted to the afterlife. The Egyptians' belief in the afterlife hinged on their understanding of the powers of the Gods to control nature. The deceased were viewed as emissaries who, by bearing gifts and sacrifices into their burial chambers, could bribe the Gods to protect their families and property. As an extension of this belief, the preservation of the body, or its facsimile, would assure the continued life of the corpse and, consequently, its continued power to act on behalf of

living relatives. Mummification techniques were highly advanced and strongly linked to an eternal afterlife. Evidence of the Egyptians' superior embalming techniques are manifest in the mummies which remain today housed in museums, no longer as spiritual emissaries but now as cultural artifacts.

Any glance at ancient preservation efforts must also acknowledge the unpredictable forces of nature. Global climates and natural phenomena have randomly contributed to the preservation or destruction of ancient artifacts. The Sumerians' baked clay tablets survived because of their placement in a naturally protective arid climate, whereas the Egyptians' papyrus scrolls perished over time in the humidity of the fertile Nile Valley. In modern times, with the rise of conservation as a science, techniques for regulating environmental factors and increased understanding of materials have contributed to new standards in preservation. Despite this knowledge, many artists are still woefully oblivious to the hazards of environmental factors and their studios reflect this. There are ways, however, to avoid recreating either the Sumerian desert or the Nile Valley.

Contemporary Artmaking

Contemporary artmaking is unique in the multiplicity of materials at hand, both manufactured and organic, with which to create. Whereas ancient artisans had only nature's bounty to work with, the modern artist has myriad media to explore. The use of traditional materials and techniques is now only one option. New technologies have inspired techniques for varying traditional art forms, such as printmaking and bronze casting, often facilitating faster results, improving durability, and offering

innovative and hybrid possibilities for experimenta-
tion. These stepchildren of technology have pro-
vided the artistic imagination with materials and
tools to stretch the boundaries of convention. Syn-
thetic polymers, acrylic paints, and neon lighting are
all contemporary developments which have inspired
new forms of art.

In the twentieth century the very notion of preser-
vation has been challenged by the deliberate use
and exploration of ephemeral materials for concep-
tual ends. Marcel Duchamp's large glass, *The Bride
Stripped Bare by Her Bachelors, Even,* with its
shattered surface revealing vestiges of wear and
aging, celebrates spontaneous effects outside of the
artist's control. For many artists, exposing the fragil-
ity and vulnerability of material has become a
metaphor for the impermanence and change central
to our modern world. In particular, much of post-
World War II avant-garde art concerns itself with
these issues of instability over permanence. Joseph
Beuys' organically decomposing sculptures speak to
process, just as Joseph Cornell's boxes built of
ephemera structured in the most fragile of containers
address issues of time. The delicacy involved in
applying increasingly sophisticated conservation
practices to the theoretical challenges posed by
contemporary art is one of the prevailing issues for
the modern conservator. How to conserve objects
which boldly claim their own mortality is a paradox
best left for those professionals charged with the
responsibility of caring for contemporary art.

The Studio

Through whatever means an artist decides to court
his or her muse, and regardless of the inherent

contradictions existing between artistic license and the life of the artwork, it is the studio which must provide the nurturing environment for the creative impulse. As the place where creative rituals are enacted, the studio, if only temporarily, is also the home for the art object.

That is not to say that artworks should automatically be immune from destruction or alteration. The artist may rightfully choose to edit or destroy works which do not withstand the critical eye. Cezanne's unrelenting self-criticism was reportedly manifest in the continual destruction of his work, which he slashed, stamped on, folded, and occasionally tossed from the window. While such tempestuous activity may be useful as a steam valve for the release of psychic tension, we may all be poorer for having fewer examples of Cezanne's work.

Perhaps the example of Picasso brings us closer to the expression of the studio as a metaphor for both creation and preservation. In one eye witness account, Picasso had placed his own small sculptures in a glass vitrine next to an assembly of artifacts, including prehistoric, Etruscan, African, and Eskimo sculptures, fetish objects, primitive idols, and fragments of stone and metal. Like an anthropological museum, Picasso linked his own work to the history of civilization and, in particular, to its cultural byproducts. With Picasso in mind, this book advances the notion of preservation as an homage to the creative process. Preservation and creativity are not natural enemies, even though at times they may appear as such in the artist's mind. With the information provided here, it should be possible to obtain a balance by giving the same care to the studio environment that goes into the making of the object.

Restoration and Art Materials

While *Caring for Your Art* addresses issues concerning the prevention of damage, it does not discuss the restoration of damaged art. In this regard, a little bit of knowledge may be more harmful than none and experimentation by the amateur may lead to disastrous results. Readers are advised to consult the wealth of conservation books in print for technical information, or to consult with a professional conservator whenever there are questions of damage or repair to an artwork. A call to your local museum should yield a list of experts in the field. We note in the bibliography some standard reference books on conservation for an introduction to the field.

This book will also not discuss in any significant detail the materials used in making art. Like conservation, the discussion of materials is the basis for another book. The bibliography includes manuals devoted to the technical review of painting and sculptural materials. It is encouraging to note that art students appear to be receiving better instruction about the consequences of poor materials on the long-term stability of their art.

Similarly, serious concerns about the potentially harmful side effects of materials have been raised by organizations such as ACTS (Arts, Crafts and Theater Safety, New York City) and the Center for Occupational Hazards (New York City). The toxic effects of materials on artists and recommendations for preventive measures are covered in *The Artist's Complete Health and Safety Guide* by Monona Rossol (Allworth Press).

The Modern Age

In the modern age, the definition of artwork or artifact has expanded beyond the rare and unique

finds from ancient cultures to include objects which may be produced in multiples or series. Book production, printing presses, and photography labs enjoy the fruits of technology and partly account for the proliferation of material. Indeed, the advances in modern research and scientific studies have allowed greater democracy in the preservation of cultural artifacts. Scientific data on the aging of organic matter are available to any interested party and applicable to any work, whether it be the last relic of a long-departed civilization or a page from last year's diary. Consequently, conservation methods, and their offshoot, preservation measures, are now summoned in common workplaces. To everyone's benefit, what was once an esoteric subject has become accessible to artists in their studios, collectors in their homes, or curators in charge of museum collections.

2

Creating a Safe Environment

I n the beginning a studio is just a space. As Lao Tzu, the Chinese philosopher, observed, space is both intangible and useful. Lao Tzu cites the purposefulness of the hole in the middle of the wheel and the empty hollow within the vessel to describe this paradox. Similarly, we can measure the physical dimensions of a space to determine its practicality, but its most striking features are the intangible ones which convey mood. For most artists, light and space create a magical mixture. It is no mystery why artists seek out light; its enveloping qualities seem to inspire and heighten visual sensation. The alchemy of space and light is different for each individual. The artist's romantic search for the perfect studio often parallels Ponce de Leon's quest for the Fountain of Youth. While a light-drenched atelier in a pastoral setting may be one's fantasy, a fifth floor walk-up in an industrial neighborhood may have to do — or vice versa.

Atmosphere is of course only one element of the physical environment. Any space poses many possibilities, and a studio is usually constructed with an eye toward both aesthetic and functional concerns. Decisions made to balance form and function within the physical limits of a space are ultimately manifestations of the artistic personality. Consequently, artists' architectural solutions are often delightful and aesthetic expressions in themselves. This tells us that a studio, whatever its limits, must first and foremost serve as a host, and perhaps even as a catalyst, to the creative activity which takes place within it. Private homes, galleries, and exhibition areas that maintain an aesthetic appeal while observing the functional needs of the space are extensions of this principle.

As mentioned in the opening chapter, the physical environment also has an impact on the art that is produced in the studio. This chapter will discuss those environmental factors —light, humidity, temperature and pollution — which bear primary responsibility for the premature wear and aging of artwork. Becoming informed and knowledgable about these factors is an important step toward caring for your art.

Progress in the science of conservation makes it increasingly possible to control the environment in such a way that works of art can be preserved for an indeterminate length of time. It is possible to create an environment in which controls on light, humidity, temperature levels, and air impurities theoretically maximize the life span of the artwork. However, these measures would preclude ever bringing the art out of storage for public view. The severity of these measures recalls the cases of children who must live in controlled environments due to a lack of

natural immunities. Isolated for their protection, these children consequently are denied the contact natural to humankind. Art objects, however sacred, are also meant to live among us, and consequently must take a few chances.

Art Materials

Before turning to the effects of the environment on works of art, it would be useful to mention briefly the self-destructive capabilities of certain materials used in making art. To some extent, all materials are in the process of deterioration. Even the materials of the highest quality, organic or inorganic, are vulnerable to the ravaging effects of time. However, some are better than others. Works of art have no natural defenses except for the inherent quality of the materials used in their construction. Along with control of environmental factors, the selection of good quality materials is half the battle in working toward the longevity of the object. Often this choice is determined by budgetary concerns, sometimes by indifference. It is no secret that quality usually commands a higher price. Artists should consider the relative benefit of quantity versus quality and choose quality materials if they want their art to last.

The good news is that inherent vice, or the presence of deteriorating agents, is an easy problem to control with the selection of archival quality materials. However, in order to prevent self-destructing activity, understanding the interaction between materials is of equal importance. Contemporary definitions of art have broadened to include art off the wall, outdoors, or installed to fill rooms, and the consequent juxtaposition of non-traditional with traditional materials presents new challenges to everyone.

Becoming acquainted with the intrinsic properties of your materials, and specifically their affinities and disaffinities to other materials, is a proper place to start. These factors are most commonly the cause of subsequent, unforseen problems. This knowledge is more or less easy to obtain, depending on the degree to which you innovate. Although one can now find information on materials in artists' manuals, on manufacturers' labels, and through consultation with art teachers and technical professionals, often the success or failure of a technique, or the combination of unusual materials can be determined only by your own experimentation.

The results of these risks may not present themselves immediately. Deterioration may be revealed only gradually and over a period of time. For this reason, it is wise to make periodic checks of completed works and record any changes that occur. Mark Rothko's works have been studied extensively due to their historic importance and offer a cautionary tale. Rothko's use of thin veils of oil paint, layered onto unprimed canvas for luminous effects, has produced less than desirable results as time passes. Visible cracking in the paint surface suggests that the interaction of his homemade paint mixture was not compatible with either its canvas support or its environment. Improper storage and handling methods are certain to have aggravated this condition.

Despite this cautionary note, familiarizing yourself with materials need not require any sacrifice in spontaneity. Quite the reverse is often true. The confidence gained through familiarity with the characteristics of your materials may result in the development of new stylistic possibilities and fresh approaches. Regardless, there is no longer any

excuse for lack of information on basic technical grounds. What the artist decides to do with that information must then become a conscious decision.

This decision does not affect only the artist. The responsibility for the health of art extends beyond its life in the studio. Apart from the desire to have a work and its ideas last, artists should consider their responsibility to collectors and, if fate allows, eventually to the public domain. Collectors are too often saddled with expensive restoration treatments, and museum curators must consider the life expectation of a work of art in their deliberations on permanent acquisitions. Neither of these situations bodes well for the acquisition of a poorly constructed object.

Supports

The support is the locus of many problems in early deterioration. In broad terms, a drawing may be defined by its use of paper as a support, a painting by the selection of a fabric or wood support. While contemporary hybrid art forms often break down this simple bilateral categorization, the primacy of the support to the health of a work remains true in any medium, whether it be a collage on paper or a photo-silk-screened canvas.

Common supports, such as paper, fabric, and wood are available in varying grades of quality, reflecting a new awareness of conservation concerns. Made of organic materials, these supports share a basic substance, cellulose. For paper supports, conservators now advise that the best quality products feature a combination of acid-free and alum-free pulp made of the purest possible fibers. Pure cotton and pure high-alpha cellulose

are the best fibers, which, when combined with acid-free ingredients, will produce a durable material, devoid of internal deteriorating agents. The relatively short-term effects of inferior ingredients — discoloration, mold growth, warping, and fiber weakening — highlight the importance of using good quality paper.

Linen and cotton are the most common natural materials used in making fabric, or flexible, supports. An inherent disadvantage to fabric supports is the fluctuation that occurs in response to environmental change. This destabilizing characteristic can be somewhat controlled, however, through application of a ground and through proper stretching techniques. This brief overview cannot properly address the relative advantages and disadvantages to variations in stretcher construction and preparation. It is assumed that by the time an artist is setting forth independently to establish a professional life, he or she will have already mastered these skills. However, the bibliography refers to several sources for proper stretcher construction.

The difference in length between natural fibers contributes to the strength and durability of the support, and for this reason pure cotton supports are the weakest. Linen fibers are longer and more resilient than cotton, and supports made from these fibers have proven to perform better over a longer period of time. Blends of cotton, linen, and synthetic fibers are becoming increasingly common, but, generally speaking, are not recommended. As each fiber will respond differently to environmental fluctuations, an uneven stress pattern is likely to result in weakness to the support and cracking in the medium. However, some manufacturers are investigating new techniques for blending fibers in a

uniform manner which will prevent this. Supports made entirely from synthetic fabrics offer promising alternatives to the inherent problems of natural fibers, but these supports have their own problems, such as limited resiliency to bending and creasing. Additionally, conservation treatments for synthetic supports are not as well explored as those for natural materials.

Rigid supports offer textural and structural advantages over flexible supports, but may pose different problems. When using solid wood, the type of wood, how it is aged, and how it is cut are factors which contribute to its longevity. Radial cut woods are recommended over tangentially cut wood. Hardwoods, such as mahogany or oak, are preferred to softwoods, such as poplar or pine. Problems most commonly encountered in a wood-based support relate to how it has been aged. Wood will expand and contract in response to the environment during the aging process. Seasoning, or controlled aging in a stable environment, will produce a wood support relatively free of dramatic fluctuation. To control the support further, panels should be appropriately sealed with two coats of polyurethane to prevent moisture penetration.

Hardboard panels, a form of pressed wood, offer a good alternative to solid wood. These panels do not include the foreign ingredients found in wood blends and eliminate the warping and moisture penetration problems common to hardwoods. Wood blends, such as laminated plywood and chipboard, have advantages over solid wood. Through their layered composition they actually lessen the stresses due to environmental fluctuation. However, since they commonly include a glue binder, attention should be paid to the level of acidity in the material.

Paper boards and good quality mat boards composed of linen and cotton are reliable supports.

This short summary on the selection of supports is meant to inform only on the most basic level. Information relating to the treatment of supports, or to the myriad varieties of paint and design materials can be found in the books listed in the bibliography which describe artists' materials and techniques. Also, manufacturers are making information about their products more available. Manufacturers' willingness to provide information about the material composition of their products is a good demonstration of whether or not they stand behind their product. Whatever motivates you to become familiar with your materials, be it the need to solve a creative problem, or the inherent satisfaction of working with good quality products, it is certain to produce long lasting and positive consequences.

The Studio Environment

If the artist limits inherent vice through knowledgeable selection of materials, the next decisions to be made for the safekeeping of artwork revolve around the environment in which it is made and stored. The amount of money you can budget for developing a safe studio environment is an important variable. However, the most basic concerns for the safekeeping of art are based more on common sense than on expensive equipment or materials.

Among the essential points to consider is the geographical location of your studio. Is it situated in the country, in the city, in a humid or dry zone? Environmental factors related to weather have a strong impact on the relative stability of your interior space and, depending on the structure of your building, weatherproofing your studio may be the

most obvious place to start. Another point to consider is your studio's placement within the building itself. Are you located on a high floor where heat rises and intensifies? Or, conversely, in a damp basement? Does your studio have adequate ventilation? If so, does the air flow come from a toxic environment such as a heavily trafficked street, an industrial area, or the air vent of a nearby restaurant kitchen? Certainly not everyone can count among their blessings a pollutant-free environment and a climate-controlled building, and these issues should be addressed.

Heat and Humidity

The following pages will discuss the damaging effects of humidity, heat, light, and pollution on works of art, and suggest methods for reducing harmful exposure. Conservators point to extreme fluctuations in relative humidity and temperature as among the most ravaging factors to the life of art objects. Under the stress of these conditions, wear and aging are accelerated and problems relating to shrinking, swelling, and drying for organic materials, and to chemical deterioration for inorganic materials, inevitably occur. Evidence of excessive or radically fluctuating humidity and temperature levels may appear in cracked surfaces or in the softening and decomposition of organic materials.

The damaging effects of temperature are codependent on humidity levels and vice versa. Relative humidity is the measurement of the amount of moisture present in the air, in relation to the maximum amount that can exist at a certain temperature. The warmer the air, the more capable it is of holding moisture. In an exceedingly humid environment, all hygroscopic, or moisture-absorb-

ing, materials are at high risk from mildew, fungus, and mold growth. If objects remain in a dry environment for a prolonged period, dehydration will embrittle and shrink organic supports, resulting in flaking, cracking, and splitting in the process of desiccation.

Relative humidity is measured with the use of specialized equipment known as psychrometers or hygrothermographs. Museums use these refined methods to determine precise readings and to assist in regulating controls. Such sophisticated equipment may be out of reach for a budget-minded artist. An easier, and less costly method, that still maintains a measure of accuracy and reliability, is the use of treated cards that respond to variations in humidity. These cards are color-coded to indicate relative levels of humidity, are fairly long lasting, and may be discarded and replaced when their recordings are no longer viable.

Ideally, temperature should be maintained at a steady seventy degrees, and humidity levels should not exceed seventy percent, or dip below thirty percent. The optimal level for humidity is around fifty percent. Keep in mind that heat may be related to seasonal change as well as to radiators, sunlight, or artificial lighting. Especially in combination with low humidity, high temperatures can cause yellowing and embrittlement.

Mold spores are encouraged by moisture, warmth, and lack of air circulation. Given the combination of these conditions, mold will certainly attack any organic material, including paper, adhesives, certain inks, and pastels, and, ultimately, will result in the decomposition of any support. If mold is visible, bringing the work of art into a well-ventilated area and exposing it to direct sunlight for about an hour will decelerate its growth. However, the visible

mold will remain and should only be removed under the supervision of a conservator. Isolate any mold-infected work and keep it unwrapped until the growth of the mold has been arrested.

Inert materials are also vulnerable to humidity. In excessively humid environments, metals may corrode and tarnish, and stone, ceramic, and glass surfaces will effloresce, or produce salts.

Air conditioners and dehumidifiers are the best preventive devices for moist climates and damp buildings. A humidifier will reduce the hazards of an excessively dry environment. Designing your work and storage areas so that they may benefit from localized air conditioning units, humidifiers, or dehumidifiers, is an economical solution for large spaces. The installation of a modest ceiling fan in lieu of more expensive air conditioning will also work toward the proper circulation of air, particularly if there is no cross ventilation in the studio.

If you plan to be away for a prolonged period, paying special attention to environmental levels may be prudent. Take extra care to provide for some means of steady air circulation and humidity regulation. As a result of daily or seasonal weather changes, humidity levels can alter by as much as twenty to thirty percent within just a few days and fluctuation in your art is certain to occur. Also, be sure that all art is stored away from exterior walls which may become damp and intemperate with fluctuating weather conditions.

Careful attention to environmental regulations should go far in preventing damage to your art. However, evidence of deterioration, such as cracking supports, flaking surfaces, and especially mold growth, may require the professional attention of a conservator.

Light

The photosynthetic activity of light transforming into energy may be a poetic metaphor for the artist's creative process. In scientific terms, however, the photochemical reaction of light with environmental factors creates real hazards to art objects. Light reacts with oxygen, moisture, and pollutants in the air to break up cellulose molecules, a process which causes embrittlement, and sometimes discoloration in organic supports. All light can be damaging, but the amount of damage depends on its intensity and duration of exposure. The daylight which filters through window glass contains ultraviolet radiation, the agent most damaging to artwork due to its ability to fade pigments rapidly. Ultraviolet radiation is present in fluorescent light, but to a lesser degree. Incandescent light, another source for artificial lighting, has few ultraviolet rays and is consequently less likely to fade surfaces. However, it does create a greater degree of heat and its installation should be calculated so that the lighting is at a sufficient distance from art objects.

Works of art on paper are by far the most vulnerable to light damage and extra caution should be taken to keep these works away from direct light sources. It is for this reason that museums often regulate the light in exhibitions of works on paper to a level that may initially seem inadequate for viewing. The eye's ability to adjust to low light levels is taken into account, and museums are prudent to take this precaution.

Direct daylight in your home or studio can be controlled. You should get in the habit of turning off lights whenever possible, regulating shutters or blinds to reduce unnecessary light, and turning pictures against the wall when not being worked on.

Avoid placing work on walls directly opposite windows, where the light is bound to be most direct. Talas, a New York City based company specializing in archival materials, distributes textile fading cards designed to help you monitor the effect of ultraviolet rays on works of art. The card consists of strips of blue wool that have been dyed with different degrees of color fastness. By covering one half of the card and placing it next to a work that is exposed to light, you can compare sides periodically to see the degree of fading over time. The strips can be purchased individually or in packs of ten.

The type of protection applied to your windows is of utmost importance, especially in studios where the presence of strong, direct light is plentiful. Translucent curtains or louvered blinds are efficient means for regulating light, but still allow for the partial transmission of damaging ultraviolet rays. Customized roll-down blinds made from ultraviolet-treated acrylic sheeting are technically superior to curtain or blinds. Although not one hundred percent protective, they will dramatically minimize damaging effects.

Fluorescent lighting should also be a point of concern, particularly for artists who work in the evening or night. Conservators advise the use of plastic covers or "sleeves" which can be fitted over fluorescent tubes to contain ultraviolet rays. The lifespan of a filter is seven to ten years.

Darkness, while desirable for works on paper, may also present some perils. Oil paintings are particularly at risk when stored in unbroken darkness. Discoloration of pigment and mold growth may occur in the absence of any light, so paintings should remain partially exposed to controlled light.

Nevertheless, a destabilized climate is far more hazardous to works of art than darkness, and climate controls should be the primary focus of your concern.

Pollution

Air pollution remains one of the ever-present hazards of urban life and, unfortunately, except for maintaining a closed, air-conditioned studio, there is no protection against the damaging effects of toxic fumes and gases. Combined with airborne soot and dust, atmospheric pollution poses a real threat to the longevity of art objects. The accelerating deterioration of ancient monuments in recent time reveals all too well the damaging effects of pollution.

Sulphur dioxide is the most harmful contaminant found in air pollution. Its effect on inert materials includes corrosion of metals and deterioration of marble and limestone. It is absorbed into the cellulose fibers of all organic-based materials, causing degradation of the support. Either through chemical deterioration or through fiber breakdown, its main effect is in the weakening of the structure of all materials. Installing air conditioning and air purifiers, or taking up residence in an unpolluted area are the only antidotes to this environmental danger. Keep in mind that air impurities enter not only through the window, but through air vents. These can easily be fitted with filters for better protection.

Soot and dust are also hazardous to art materials. Keeping a clean work environment is a lot easier than combatting air pollution. Studio cleanliness should become an integral part of your work habits. Apart from visibly marring the surface of your work, accumulated dust and grime have more insidious effects. Dirty environments encourage the growth of certain types of mold and also invite the presence of

insects. Be especially careful not to leave food or beverages in the studio, since these will certainly attract insects. If insects are seen, remove all works of art, and fumigate the area with a mild insecticide. Insect-repellent strips placed in vulnerable areas, such as the damp and dark corners that insects like to inhabit, act as effective deterrents. Insects are also attracted to organic materials. Flour paste and glue sizing found in paper are particular attractions. This risk can be controlled only through proper storage measures.

Additional preventive measures to protect artworks from the hazards of air impurities, light, heat, and humidity will be discussed in the next two chapters. Proper storage and presentation measures are central to preventing damage. Together with the control of environmental factors, the information outlined in these three chapters forms the foundation for the safekeeping of your artwork while in storage or on display.

Chapter 2 Checklist

Environmental Controls

❑ Hygrothermograph or humidity cards
❑ Thermometer
❑ Humidifier and dehumidifier
❑ Air conditioning unit or ceiling fan
❑ Light fading strips
❑ Flourescent light sleeves
❑ Blinds, shutters, or ultraviolet-treated acrylic film
❑ Air vent filters
❑ Insect-repellent strips

Selecting Art Materials

The materials you select and the type of support you use can have long-term consequences:

❑ Limit inherent vice by selecting archival quality materials
❑ Check manufacturers' labels for product identification
❑ Learn about the compatibility of materials you combine
❑ Make sure that cellulose products are acid-free

The Studio Environment

Your interventions can reduce harm caused by the environment:

❑ Determine how best to weatherproof your studio
❑ Keep your studio well-ventilated
❑ Establish controls to regulate temperature and humidity levels
❑ Reduce light levels whenever possible
❑ Control direct daylight with blinds, shutters, or U-V treated acrylic film
❑ Minimize air impurities with filters and air conditioning
❑ Keep the studio clean and free of clutter

3

Handling and Storing Your Art

J ust as selecting good quality materials and being aware of environmental hazards are essential to the health of your artwork, mishandling and improper storage may contribute to damage. Common sense, organization, and respect for the physical properties of your art are key factors in combating negligence and, when combined with the practical instructions outlined below, will result in a safer studio environment. The use of archival materials in storage, informed handling methods, and proper storage units will be the focus of this chapter.

The Use of Archival Materials

The pyramids and tombs of our Egyptian ancestors stand as bench marks in their approach to preservation. Built for housing the deceased and their material accouterments, these elaborate structures were meant to protect their contents against pillaging, the elements, and other evil intrusions. As exemplary manifestations of preservation, they may be viewed as early civilization's prototypes for art

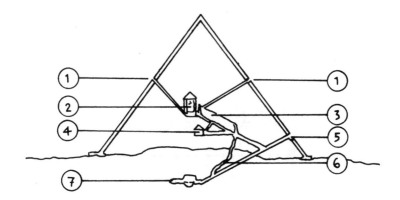

1. Air Shafts
2. Large Burial Vault
3. Grand Gallery
4. Small Burial Vault
5. Entrance
6. Connecting Shaft
7. Underground Chamber

**FIG. 3.1 THE EGYPTIAN SOLUTION TO CONSERVATION;
THE PYRAMID OF CHEOPS: CROSS SECTION**

storage. The parallels between ancient and modern
approaches to preservation continue when we
compare the Egyptians' mastery of chemistry with
modern scientific advances in the field of conserva-
tion. In the same spirit that motivated the Egyptians
to develop embalming techniques for the protection
of afterlife, contemporary conservators have adapted
advances in science to unravel the mysteries of
material decay and, consequently, to prolong the
life of art. Well-equipped laboratories able to study
the chemical composition of materials with increas-
ingly refined technologies offer improved conserva-
tion treatments for art of all ages. X-ray technology,
for example, is used to reveal invisible undercoatings,

and sometimes even former images, the results of which shed new light on the understanding of masterpieces and their makers.

Conservators have long recognized that one of the most common causes of deterioration in artwork is the use of acidic materials. Often intrinsic to the primary materials used in making art, acid contamination can also occur through contact with acidic secondary materials, such as mat boards, adhesives, plastic sheeting, or any kind of backing board. Proof of this is unfortunately ever present in yellowed and brittle adhesive, in "mat burns" — marks transmitted by acidic mats onto the surface of the work — and in the contamination of paintings from acidic backing boards.

Acidic secondary materials are certain to harm your art if there is prolonged direct contact, but even temporary exposure to them can cause damage. The use of archival quality materials for storage and presentation purposes is the best way to counter these dangers. A well-stocked studio should have on hand plenty of acid-free tissue paper, glassine, blotters, and corrugated cardboard. Taking preventive measures right from the start, and well before the visual evidence of long-term damage presents itself, will produce the best results in the long run.

Materials are usually considered archival if their acid content is zero. PH is the measure of a material's alkalinity or acidity and ranges from zero to fourteen. High acidity is reflected in a low PH, while a high PH means acid levels are low. An acceptable range for art materials is between 6.5 to 8.5. Your material should not register an acid level much below pH 7.0, but may go as high as 8.5 when used to counter an acidic environment, such as buffered paper used to protect openly stacked

works on paper. Keep in mind that the stability and longevity of the product depend not only on its acid-free status, but on the quality of its fiber or synthetic content as well. Product identification is key to selecting materials. Any product that does not specify its content or indicate that it is of archival quality on the label should be avoided. There are plenty of products on the market that are reliable and safe, and these should be the focus of your selection. As archival quality materials have become increasingly standard in art supply catalogues, it is now possible to select safe products that meet both aesthetic and budgetary standards.

Handling Your Art

The consequences of simple negligence form the bulk of damage to artwork. Correcting bad work habits can make a significant difference to the safety of your art. Determining the best way to carry your artwork is one way to reduce risks. Lifting paintings directly from the top or from stretcher bars causes stress to the support and weakening in the joins of a stretcher or frame. Paintings should always be supported equally by two hands on either side to counter these stress factors. If the painting is small, carry it with the image facing you, so that the stretcher bars or backing board will form a protective armature against puncturing. Holding a larger work in this manner might create a risk of rubbing the surface with your clothes, so it would be better to turn the face outward and carry it carefully. When holding a work from the back, be careful not to slide your hand between the stretcher bar and the fabric as the pressure might cause distortions on the surface.

Works of art on paper are particularly vulnerable

to damage and overhandling is a major hazard. Avoid carrying and lifting unmatted works by their corners. Over time, the continual stress will weaken the fibers and result in tears, as well as produce irreversible smudge marks. When leafing through a stack of works on paper it is best to lift each sheet separately, supported from either side. Sliding the paper between the index and third fingers, rather than grasping it between the thumb and index finger, will help to prevent fingerprint accumulation. Large works on paper should be held from opposing corners, allowing the paper to slack comfortably. When transferring an unframed or unmatted work on paper, slide a rigid support underneath the back of the sheet to carry it.

The accumulation of fingerprint grime on the surface of art is among the most common forms of damage, and one that is particularly difficult to reverse. Composites of oil, sweat, acid, and dirt, when ingrained in the surface of paper or canvas, eventually result in the breakdown of fiber, not to mention an unsightly appearance. Unprimed canvas and heavy all-rag paper are particularly vulnerable to damage due to their textured surfaces and permeable fibers. Stone, too, because of its rough, untreated surface, is a perfect host for fingerprint dirt. The build-up of acidic fingerprints on the surface of metal objects, particularly bronze, causes corrosion. Wearing white cotton gloves when handling works of art is a good preventive measure. At the very least, keeping one's hands clean will lessen this type of damage.

Heavy sculptural objects should be transported by a dolly, and braced with two-by-four-inch boards where necessary. Fragile objects should never be lifted by protruding parts, such as handles, decora-

tive elements, or rims. Supporting such objects with two hands from the base or most structurally sound area is a safer method.

Paintings, framed works on paper, and objects that remain out in the studio should be elevated from the floor by placing them on pads, bumpers, or carpeted blocks of wood. This will prevent dirt and dust from contaminating the bottom edge and also diminish risks in the event of spills or flooding.

A frame or mat will greatly reduce the risks associated with handling two-dimensional works of art. These measures, and their importance for the safekeeping of your art, form the subject of the following chapters, in which methods and guidelines for matting and framing are discussed.

Housing Your Artwork

Just as you do not want to expose art in the studio to excessive heat, dampness, and light, it should be of equal importance to protect it from these elements in the storage area. Storage units should be positioned in a well-ventilated area, away from external walls, radiators, direct sunlight, and overhead lighting and drafts. Specific studio hazards to guard against include housing your art in dangerous proximity to working equipment and to toxic substances. Construction equipment, such as sharp tools, drills, and saws, should be stored separately to prevent accidental damage. Similarly, paints, paint thinners, cleaning agents, or any kind of toxic substance should be kept away from the storage area. The storage area should be easily accessible, relatively free of clutter, and kept free of dirt and dust.

A storage area can have practical purposes apart from the protection of your art. A logical arrange-

ment can indicate curatorial categorization, such as organizing works by year, medium, or in order of importance, and can assist in keeping track of inventory. You should take time to consider what system works best for your art before approaching the design of your storage units. In this regard, you may want to consult Chapter 6, which discusses systems for documenting inventory.

Storage Units
Storage units will vary according to the size and type of your art. A simple and general unit might include racks for paintings, shelves or drawers for stacking open or boxed works on paper, and additional areas for storing materials and small objects (Figure 3.2). The most practical unit is one which offers maximum flexibility. Painting racks and shelving units should be designed so that their structures are easily changeable to accommodate variations in the dimensions and weight of stored work. If you use plywood as your building material, make certain first to protect the surface with several coats of polyurethane to limit acid migration.

Storing Works of Art on Paper
When storing works of art on paper, it is essential to cover all surfaces to protect against abrasion, dust and dirt, and light exposure. Whether housed in boxes, portfolios or folders, in closed drawers or on open shelves, it is recommended that all works on paper, matted or unmatted, be interleaved with acid-free tissue paper. Lightweight, and available in translucent or opaque varieties, tissue paper should also be used to line the bottoms of shelves and drawers. The dimensions of interleaving sheets for open stacks should be uniform and large enough to

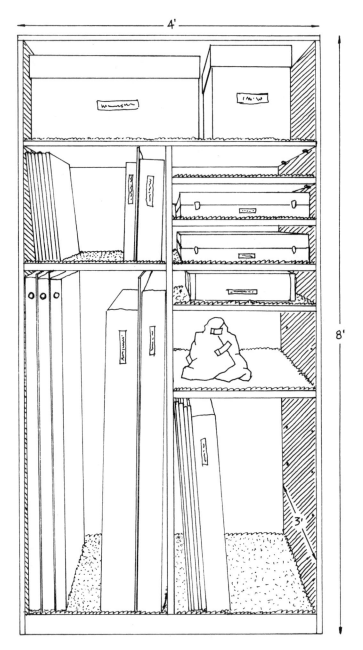

FIG. 3.2 GENERAL STORAGE UNIT

protect the biggest work in the stack. For works stored in boxes, portfolios, or folders, sheets should be sized to the dimensions of the storage container. With matted works, the interleaving sheet should be slipped between the overmat and the work of art so that the overmat holds it securely in place.

Unframed works on paper can be stored simply by stacking them with tissue paper in flat filing units or on open shelves (Figure 3.3). Open shelving does not offer optimal protection for works on paper, but at the very least removing works from direct sunlight and protecting against dust is a good start. Shelves which are made to pull out will facilitate safer handling of stacked works of art on paper.

For best results, group works together according to size. Variations in size jeopardize both large and small works that are stored together. Risks to larger works include abrasion by the edges of small works, while smaller works may be overlooked and slip out. Small works may also leave border mark indentations on larger works if stored together over long periods of time. The rigid supports of matted work reduce these dangers to some extent, but for the best care and efficient handling, similar size matted works should also be stored together.

Works on paper are best protected when housed in folders, portfolios, or in boxes. Loose folders will prevent dust and dirt from settling on and around unmatted works on paper, but enclosed portfolios and storage boxes are even better protection against these intrusions. When housing works in portfolios, flat files, or on shelves, make certain that non-acidic paper is used to line both the top and bottom of the stack to guard against the migration of any residual acids.

Storage boxes (referred to as solander boxes by museum suppliers) offer maximum protection for

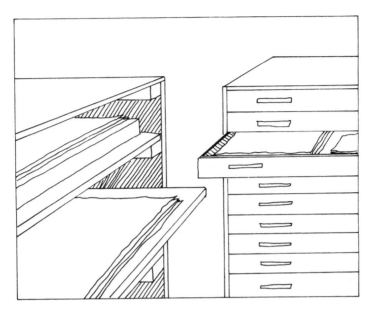

FIG. 3.3 STORAGE FOR WORKS OF ART ON PAPER

matted or unmatted works on paper. While com-
mercially available through art suppliers, storage
boxes can be made easily, and at less cost, in the
studio. Box dimensions can be customized accord-
ing to the size of your paper, but suggested standard
sizes are 8 by 10, 11 by 14, 14 by 18, or 16 by 20
inches. Storage boxes are best made from 1/4 inch
acid-free foam-cored board, a lightweight, semi-rigid
material which is available in art supply stores.

To construct a box, refer to the general pattern
outlined in Figure 3.4. The pattern is identical for
top and bottom. However, to allow the top to slide
comfortably over the bottom it should be made
slightly larger, relative to the thickness of the mate-
rial you use. For example, if you use a 1/4 inch
foam-cored board, measure the top pattern a 1/4
inch larger on all sides, or, in other words, 1/2 inch

larger in length and in width. Where indicated, score the pattern with a blunt tool, such as a screwdriver. Fold and seal all four seams of the box top with pressure sensitive tape. Sealing only two ends of the bottom box will form a flap that will make handling of the works easier. Storage boxes may be stacked on shelves and labeled on the front for easy identification.

To retrieve a work that is stored in a stack, begin from the top of the stack by lifting and transferring

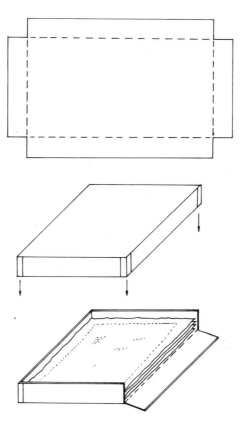

FIG. 3.4 STORAGE BOX FOR WORKS ON PAPER

each work individually to either a clean blotter or into the top part of the box until the specific work is reached. When lifting and moving works, make sure that the interleaving remains in place over the surface of the image.

Storing Paintings or Framed Works on Paper
Most modern museums use some form of sliding screens to store paintings. The paintings are attached to a movable screen by hooks from the back. This method assures that paintings are elevated from the floor, are relieved of the stress and surface contact associated with stacking, and are easily accessible for viewing. An artist adept with construction tools may build this type of storage system, but most artists rely on standard painting bins or racks to house work. Racks and bins are adequate methods for storage if the following considerations are taken into account.

The painting bin should be constructed so that paintings do not rest on the floor. Carpeting the bottom of the bin or rack will allow the painting to slide in and out smoothly and with less effort, and will also protect the frame or bottom edge from abrasion. Paintings should be grouped together in storage according to size. Large, medium, and small works should be housed in separate bins to prevent smaller works from leaning into the surface of larger ones. They should be stacked vertically in groups of not more than approximately five or six. Too many paintings stored in one bin can place excessive weight on surfaces and supporting structures. Paintings should never be packed tightly into a space. There should be enough free room allowed within each area to separate and remove works easily, and to allow air to circulate freely.

Surface protection is probably the most critical factor to the well-being of a stored painting. Unprotected surfaces risk being punctured and abraded from adjacent works. These risks can be avoided by separating canvases from one another with corrugated cardboard spacers. For maximum protection, paintings should also be wrapped in acid-free glassine paper to limit their exposure to dust, dirt, and light, and to protect against handling. Artists who like spontaneous access to their paintings as they work may be reluctant to wrap them. It is suggested that paintings be separated, leaving those of current interest exposed and those less likely to be viewed wrapped. Most well made oil paintings will not suffer greatly from exposure in the short term. Surfaces can also be damaged by hooks, wires, and other types of hanging hardware that are left on stretchers. Hardware devices, especially protruding varieties, can act as sharp weapons and should be removed from the work before placing in storage.

Increased pressure resulting from the weight of works leaning against one another during storage can have adverse effects. Before storing, make sure that stretchers are constructed to distribute tension evenly and that the support is stretched tautly. Unevenly constructed stretchers will produce distorted surfaces over time and loosely stretched canvases risk being imprinted with marks from the stretcher bars. Make certain that stretcher bars are never leaning onto the surface of an adjacent painting. Damage due to pressure is often not visible at first, but eventually will reveal itself in cracking, discoloration from grime deposits, and distortion. For these reasons, you should exercise caution by using separators to protect the support from any external pressure points.

Protecting Fragile and Wet Surfaces

Cardboard frames are an easy and handy method for providing additional protection to the surface of a work. They are also a particularly useful method for storing paintings whose surfaces are still tacky. Cardboard frames, like permanent types of frames, form a protective ridge around the painting's perimeter to prevent surface abrasion. The raised edge will also keep the glassine from adhering to a tacky surface.

Two versions of cardboard frames are illustrated in Figures 3.5 and 3.6. In the first version, four strips of cardboard are cut to form the frame. Measure the length of each side of the stretcher accurately to determine the length of the strips. The width of the strip should be calculated by adding 2 inches to the depth of your stretcher, and another 2 inches for the back attachment. Score the cardboard pattern with a blunt instrument where indicated. Bend the frame around the stretcher, secure the back to the stretcher with screws and washers, and seal the four corners with pressure sensitive tape. To construct the second version (Figure 3.6), trace the outline of the back of your work onto a single sheet of corrugated cardboard. Determine the width of the flap by adding two inches to the depth of the stretcher. Secure the flat back of the cardboard frame to the stretcher with washers and screws. Fold and seal the frame edges in the same manner as described above.

It is best to leave wet paintings out to dry over time in the studio, but limited working space may preclude this possibility. An easy method for storing wet paintings is to secure them in pairs with simple wood braces (Figure 3.7). Place two paintings parallel, at a distance of approximately two inches

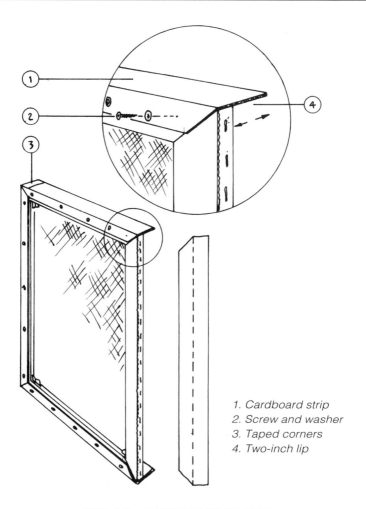

1. Cardboard strip
2. Screw and washer
3. Taped corners
4. Two-inch lip

FIG. 3.5 CARDBOARD FRAME

apart (more if the canvas happens to be slack), with
surfaces facing inward. Cut two pieces of wood,
measuring approximately 6 by 2 by 1 inches each,
and place across the top edges to form a bridge
between the paintings. Secure by nailing to each
stretcher. It is recommended to use at least two
nails for each side of the wood braces for maximum

security. Selecting a nail size which can hold the brace to the painting but still protrude slightly from the top will facilitate easy removal with a hammer. After securing the first side, turn the pair over, being careful not to allow the painted surfaces to touch, and repeat the procedure on the opposite side. Place the pair in the painting bin and protect with cardboard dividers.

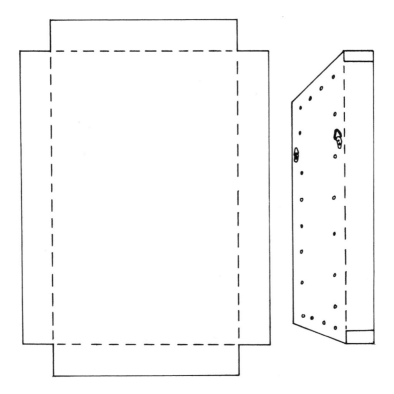

FIG. 3.6 CARDBOARD FRAME WITH BACK PROTECTION

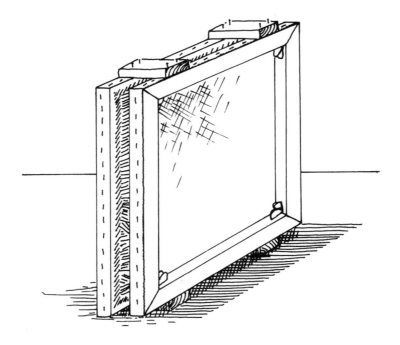

FIG. 3.7 STORAGE METHOD FOR WET PAINTINGS

Rolling Paintings — Pros and Cons

It may be impractical to store very large paintings on their stretchers. While standard wisdom does not recommend rolling any work of art, this technique may be the only solution for storage, especially in tight quarters. This method of storage is not recommended for thickly painted works or for works which bear any form of surface incrustation, as these surfaces are much more likely to crack when bent. It is better suited for thinly painted canvases with pliable paint layers, such as acrylics. In these exceptional cases, a few notes of caution may help to limit some of the dangers associated with rolling.

Paintings should be rolled face out onto cardboard tubes. The larger the diameter of the tube, the

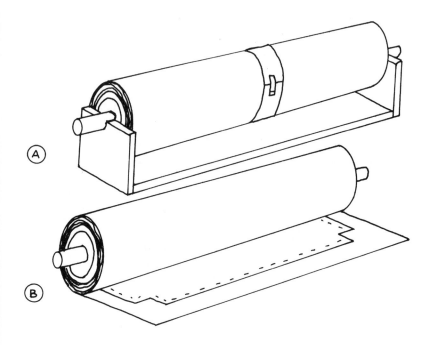

**FIG. 3.8 (A) STORING ROLLED CANVASES
(B) ROLLING WORK ON CANVAS**

better. Tubes made from archival material are available, but are expensive to purchase. For a less expensive alternative, use a regular thick-walled cardboard tube and wrap it entirely in acid-free glassine. Remove the canvas from its stretcher carefully, making sure that no staples remain (Figure 3.8b). Place it face down onto a sheet of glassine that is cut to extend at least six inches beyond the measurements of the work, and fold the border of the glassine over the top edge of the painting. Using this edge, secure the painting onto the tube with pressure sensitive tape. Make sure that the image side is facing out. Roll to a snug fit and tape the

end. Avoid rolling too tightly. A rolled work should not be rested on any flat surface to avoid the pressure of its own weight. Instead, it should be suspended from a pole (Figure 3.8a).

Storage for Sculpture
Sculpture can take up a lot of storage space and an artist who works in a three-dimensional format should take account of this fact when designing a storage area. Large storage boxes and areas designated for freestanding sculpture will supplement the storage unit.

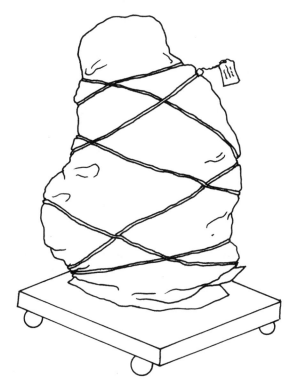

FIG. 3.9 WRAPPED SCULPTURE ON DOLLY

Most large sculpture can be stored freestanding out of harm's way, and simply draped with a moisture-absorbent drop cloth for protection against environmental factors. Simple cotton sheeting, woolen blankets, or heavy felt padding, depending on the fragility of the surface, are recommended for drop cloth use. Plastic sheeting is not advised because its static electric properties will attract dust and dirt to the surface and, being impermeable, it will trap any condensation.

Heavy sculpture should be stored directly on a wooden dolly to facilitate handling and moving. A strong string or piece of twine should be used to wrap the cloth around the form of the sculpture, both to secure the cloth and to give a relative indication of its shape (Figure 3.9).

Storage Boxes

Storage boxes are a safe method of housing smaller and lightweight objects. While such objects can simply be placed on storage shelves and covered with drop cloths or wrapped with glassine or tissue paper for protection, storage boxes offer greater protection against handling and environmental hazards. Storage boxes are particularly recommended for housing sculpture that is composed of many parts. In this case, the object may be disassembled, each piece wrapped and marked individually, and placed in the same container.

Storage boxes are easy to make at home. The boxes should be constructed from acid-free corrugated cardboard and secured with pressure sensitive tape. Figure 3.10 illustrates a simple pattern for making your own storage boxes. The pattern can be adjusted to any size, but practical consideration should be given to whether the cardboard will

support the weight of the sculpture, especially if it is made from bronze or stone. Be certain to make the box large enough for two hands to reach in and handle the sculpture comfortably. You can further protect a sculpture by packing it loosely with crumpled sheets of acid-free tissue paper or with acid-free foam rubber. Keep in mind that this will only help to protect surfaces against minor bumps and jars associated with studio movement and will not be sufficient padding for travel.

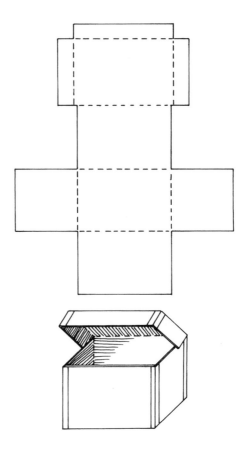

FIG. 3.10 STORAGE BOX FOR SMALL SCULPTURE

Preparing works to weather the traumas of travel requires the implementation of more extensive packing precautions. Guidelines and methods for assuring the protection of works of art in transit are presented in Chapter 8.

Chapter 3 Checklist

Storage Materials
- ❏ Tissue paper
- ❏ Glassine
- ❏ Blotters
- ❏ Corrugated cardboard
- ❏ Foam-core board
- ❏ Pressure-sensitive tape
- ❏ Soft drop cloths or padded blankets

Use Archival Materials
PH balanced materials will protect and preserve your artwork

- ❏ Use only acid-free materials next to your work
- ❏ Avoid using tape, glue, or other binders directly on your art

Handle Your Art Carefully
Damage from negligence and mishandling can be avoided by establishing the following work practices:

- ❏ Keep hands clean
- ❏ Use cotton gloves when handling vulnerable surfaces
- ❏ Only carry work that you can comfortably and safely handle
- ❏ Carry paintings with hands on either side of the stretcher
- ❏ Never place pressure on a canvas from the back
- ❏ Avoid overhandling works on paper
- ❏ Use a dolly to support heavy sculpture
- ❏ Elevate works of art from direct contact with the floor

Make the Storage Area Work for Your Art
Like the studio, the storage area should maximize protection and minimize harmful factors.

❑ Position art storage away from environmental intrusions and toxic substances
❑ Flexible storage units will accommodate all types of artwork
❑ Protect works on paper by housing them in boxes, portfolios, or folders
❑ Do not overstack paintings in bins
❑ Use cardboard separators and glassine wrapping to protect painting surfaces
❑ Cardboard frames and braces protect fragile and wet surfaces
❑ Avoid rolling paintings unless absolutely necessary
❑ Drape sculpture with soft, absorbent cloth

4

Matting Works of Art on Paper

O nce you have determined the most suitable means for storing your artwork, you may want to investigate further options for assuring its longevity. Matting and framing are the standard methods for protecting two-dimensional works of art. This chapter will focus on methods for encapsulating and matting works of art on paper, while the next chapter will discuss framing methods for works on paper and on canvas.

Essentially, matting and framing achieve two purposes. Mats and frames made with archival quality materials insulate the artwork in an acid-free environment, limiting damage from light, heat, humidity, and pollution. Framing and matting are also methods for protecting art against the dangers of handling. Artists are often called on to present their work, in the studio or off the premises. This involves a degree of handling which, given the law of averages, at some time may result in damage to the artwork. The rigid structure of a mat or frame supports the work against jolts and allows it to be handled without directly touching the surface.

Works of art on paper are among the most vulnerable of art objects. As described in the chapter on storage, even simple steps, such as placing interleaving sheets between stacked works on paper, can do much to protect them against damage. However, since art on paper is probably the most fragile type of art, you may want to consider mounting your work by attaching it to a rigid support or by fully enclosing it in a mat. Securing art on paper to any kind of archival board will protect it against inadvertent folding or bending. In particular, a rigid support will lessen the risk of damage to corners, which are so often used as handles for carrying the work. When handling or touching art, you also risk transferring dirt, sweat, oil, traces of food, or anything with which you were last in contact, onto the surface. A mount or mat provides something to grasp other than the work of art.

Common Mistakes

One of the most common mistakes made in mounting works of art is to secure the work of art to a board with tape. Adhesives on most tapes are acid-based, will yellow with age, and will leave an unsightly residue that is damaging and very difficult to remove. Pressure-sensitive tapes, gummed tapes, or water-soluble tapes should never be placed directly onto the surface of the work. When using tape on any secondary material, archival varieties should be used.

Pasting the sides or entire back of a work to a mount is another common, and particularly destructive, mistake. Like adhesive tape, glue becomes brittle with age and will transmit acid through the back of the work. Dry mounting, the term used to

describe this method, is also responsible for stress to the support. By fixing the work to its mount, this technique inhibits the natural expansion and contraction of organic material and eventually causes the fibers of the paper to weaken. Dry mounting is an especially difficult, if not impossible, procedure to reverse and should be attempted only by a trained conservator.

Reversibility is one of the basic principles of modern conservation practice. As a general rule, if a procedure cannot be easily undone, it is not recommended. For this reason, the simplest methods and most basic materials are usually the best. In preservation, less is usually more.

Proper Materials

Mounts and overmats should always be made from archival material. Matting boards should be acid-free and made of all-rag fiber. They can be purchased in three thicknesses, 2-ply, 4-ply and 8-ply. The 4- or 8-ply thicknesses are generally recommended for matting works on paper. A 4-ply can be used if the work on paper is flat. If the paper used in making your art tends to buckle, an 8-ply mat is preferred for its additional support. When you are ready to frame the work, the thickness of an 8-ply overmat will protect the glazing from coming into contact with the surface of the paper.

When mounting a work on paper to a support, it should always be hinged. Japanese paper is the preferred material for making hinges and a wheat or rice starch paste is recommended for pasting the hinge. Mat board, hinge paper, and starch may be found in any well-equipped art supply store.

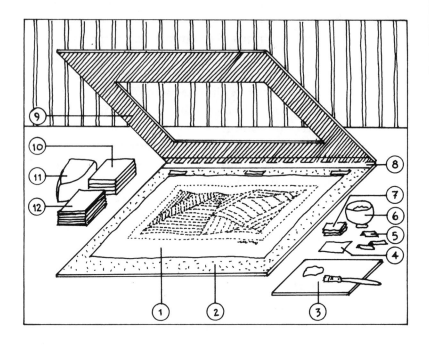

1. Work of art
2. Back of mat board
3. Pasting out board with
 short bristle brush
4. Plastic card
5. Tissue hinges
6. Starch paste

7. Nylon webbing
8. Linen tape
9. Window mat board
10. Glass plates
11. Weight
12. Blotters

**FIG. 4.1 A MATTED WORK WITH TOOLS AND
MATERIALS FOR MATTING**

Matting a Work — Step by Step

Philosophically, it is a good idea for an artist to maintain as much control as possible over the care of his or her work before it leaves the studio. Housing a work on paper in a mat gives the work a head start by greatly reducing its risk level once it is out of your hands. While mounting is an adequate way of protecting it during storage, matting is recommended if the work is to leave the studio, if you anticipate framing it, or if the work is particularly fragile. The overmat offers additional protection to the surface of the work and, when framed, it provides the proper breathing space necessary to maintain between the glazed surface and the work of art.

A professional matting procedure can be accomplished in your studio with little equipment and at a relatively low cost. The procedure will require careful attention each time, but will become more routine with practice. Figure 4.1 illustrates the equipment used in a basic matting procedure. As you follow the step-by-step directions for matting a work of art, you may want to refer back to this list for identification of the items discussed. It is recommended to read through the entire procedure once before attempting to mat your work.

Step I. Aesthetic Choices. The first decision to be made when matting a work on paper is whether or not to float it. By this, we mean the choice of exposing the whole sheet with its edges through the mat window, or covering its edges with the mat window. Naturally, the work will be more secure if its edges are held in place by the overmat, but this remains an aesthetic decision left up to the artist or owner of the work. The artist should keep in mind

that the decision to float or cover edges will serve as an indicator of his or her viewing preference once the work leaves the studio.

Step 2. Making the Hinge. A hinge should be viewed as an extension of the physical attributes of your paper. Its fiber content and weight should be proportionate to your artwork. Ideally, the hinge should be slightly weaker than the paper so that it, rather than the work, will be the first to tear with any sudden stress. The color of the hinge should be close to that of your artwork for general aesthetic reasons. Particularly if the paper is thin, a compatible hinge will blend in and not create a shadow on the surface.

A hinge is made from long-fibered Japanese paper. The size of a hinge is usually 1 to 1 1/2 inches wide by 1 inch long, its width varying slightly according to the size of the artwork. As most stress is borne close to the corners of a work, a hinge wider than 1 1/2 inches will not substantially increase its support capability. A work of art can usually be supported by a hinge on each top corner, but if the work is oversized and seems likely to buckle, you may want to add additional hinges along the top edge.

The long, strong fibers of Japanese paper are ideal for the structural support of a hinge. Traditionally, the paper is pulled apart, rather than cut, to make a feathery edge. These feathery fibers help in blending the hinge edge with the paper, provide a texture for the paste to grasp, and create a strong support. To make a hinge, you can follow one of two techniques. After marking the dimensions with a pencil, either fold the paper along the line, dampen its edge, and then tear apart at the fold, or, apply water to the lines with a small paint brush, using the edge of a straight ruler, and then pull the paper gently apart at

the wet line. In either case, you should be able to see the long fibers extending from the edge of the paper as you pull it apart.

Step 3. Making the Paste. Archival paste is a simple mixture of starch and water. Wheat or rice starch, both natural archival materials, are the choice of most conservators. Mix four tablespoons of the starch to one cup of warm water and then heat the mixture over a double boiler to a simmer until it becomes transparent (about ten to twenty minutes). The consistency should be like pudding. Cool the mixture by placing the pot in cold water and stir to prevent lumps from developing. The paste is best when it is fresh, but it can be made and stored in a refrigerator for up to several weeks. Keep an eye on its freshness. If mold appears, or if its texture becomes too gelatinous it must be discarded.

Step 4. Mounting a Hinge. Before securing the hinge, place your art face down on a clean blotter. Fold the hinge in half lengthwise over a piece of flexible plastic, such as Mylar. Apply a thin layer of paste over the top half, brushing from the middle outward, in the direction of the fibers. The paste is strong and a thin layer should suffice. Too much paste may result in a buckled hinge when it is dry.

Using the piece of plastic as a support, position the hinge on the back of the work of art so that the fold is at the top and the hinge is lined up with the right angle of the corner edge. Press the hinge to the paper, gently blotting excess paste with a paper towel. Do this for both top corners, and the middle if necessary.

Step 5. Drying the Hinge. A hinge must be held flat with a weight while it dries. First, extend the flap of the hinge so that it is unfolded. Place a non-

absorbent material such as nylon webbing over the extended hinges. This material will prevent the hinge from sticking to the top blotter while it dries. Next, position a clean blotter over the back of the art and place a rigid support, such as a sheet of plate glass, plastic, or a wooden board, on top to maintain overall flatness and weight distribution. Finally, weights should be placed on top of the rigid plate. You can be creative in your selection of weights — a box of nails or weighted tape dispenser are fine substitutes for store-bought varieties.

The hinges should dry within one half hour. Check the hinges periodically, adjusting or switching the top blotter so that a continual dry surface is next to the hinge. This will assure that the hinges dry in an even and stable manner. When they are no longer cool to touch, it is safe to assume that the hinges are dry. Pull slightly at the hinge to make sure that there is a strong bond between it and the artwork. If the hinge is loose, remove it, reapply the paste, and dry again.

Step 6. Determining Mat Dimensions. The overall size of your mat is determined by first calculating the dimensions of the mat window and then adding the dimensions of the mat margins. When covering edges, the window size will be related to the edges of the image. There is a degree of flexibility in how close the edges of the mat are to the edges of the image. You may want to use the mat window to crop your image, or conversely to make a border margin. Keep in mind that details such as a signature extending below the image, or the plate border of a print, might require visual adjustments. If you are floating the work, the window size should equal the exterior edge of the paper plus a 1/4 to 3/8 inch margin, depending on the squareness of the paper and

any irregularities on its edges. It is standard to indicate dimensions first by height and then by width.

Once the dimensions of the window have been determined, the size and ratio of the mat margins are calculated. Common practice is to give the bottom margin a slightly larger dimension than the top margin for visual weight. The dimensions of the sides are usually equal to those of the top. A standard margin ratio for average size works is 3 1/2 inches for the bottom and 3 inches for the sides and the top, but these dimensions may be decreased or increased proportionately according to the scale of the work.

The exterior measurement of the mat board is calculated by combining the window and margin dimensions. For example, if the window is 6 by 5 1/2 inches, and the margins are a standard 3 1/2 inch bottom by 3 inch sides and top, then the mat will measure 12 1/2 by 11 1/2 inches.

Step 7. Cutting the Mat. Draw your mat dimensions with a pencil onto two mat boards, making certain that the measurements are identical. Using a sharp utility knife and a metal straight edge, cut the sheets carefully and check that they are aligned by placing one on top of the other. Next, examine the two boards and select the cleanest side for the face of the window mat. On the back of that side, draw the dimensions of the window. Be careful to cut the window accurately to avoid a messy or ragged edge.

You may want to practice handling the utility knife by cutting some scrap pieces of mat board before attempting a finished mat. Short, repetitive strokes offer a more controlled technique than trying to make the cut in one hard stroke. It is important to use a fresh, sharp blade each time you cut. After you have cut the window, minor rough edges can

be smoothed with a nail file. A softer finish can be achieved by burnishing the edge with a hard object, like a spoon or a stone.

A more aesthetic and professional looking beveled edge can be obtained by cutting with the aid of a professional mat cutter, as opposed to a simple utility knife. Various models are available in any art supply store and may be a good investment if you plan to do a lot of your own matting. Keep in mind that it will require some practice to master these techniques.

Step 8. Hinging the Boards. The two boards are always hinged together on the longest side, regardless of whether the work of art is horizontal or vertical. Accordingly, the seam will appear either on the left side or on the top of the mat. Position the two boards next to each other on a flat surface, with the edges to be seamed adjacent to one another. The two inner sides should be facing up like an open book. A gummed linen tape is typically used to fasten the boards. Cut a strip of tape the same length as the longest side, moisten it with a sponge, and quickly apply to the inner seam, wiping and blotting any excess moisture with a firm stroking motion. Close the mat to assure that the edges are aligned. Allow to dry, then trim any excess tape.

Step 9. Positioning the Artwork. Position your artwork face up under the window, making sure to center it carefully. Once centered, cover the surface with a clean blotter. The blotter should be smaller than the window, but large enough to adequately cover the image. Place a weight on top of the blotter. The mat should open freely, with the work of art secured against the bottom board.

Step 10. Hinging the Work to the Board. Once

the work is secured by the weight, extend the flaps of the hinges from behind the paper. These flaps will now be fastened to the board in a T formation by pasting a strip of Japanese paper on top (Figure 4.2). This top strip should be measured and cut to extend 1/2 inch beyond the three sides of the exposed flap. Paste and apply this piece over the flap in the same manner as described in Steps 4 and 5.

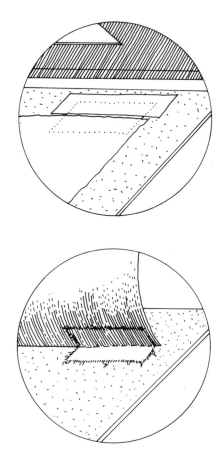

**FIG 4.2 & 4.3 HINGING METHODS FOR COVERED AND
EXPOSED EDGES**

Variation for Matting an Exposed Edge

Rather than securing hinges in a T formation, the hinge for a floated edge is concealed by turning the flap under the paper and pasting it directly to the bottom board (Figure 4.3). For best protection, a floated work should be hinged at all four corners or, if the work is oversize, along all four edges at intervals of approximately 6 inches.

Follow the directions as outlined above for applying hinges to the artwork, making sure that the fold of the hinge is always positioned at the edge of the sheet. After weighting the work on the bottom mat extend all of the flaps from behind the paper. To apply the hinge, slide a piece of flexible plastic under the flap and brush paste onto the exposed side. Lifting the edge of the work with one hand, gently turn the flap under with the other hand and secure it to the board. Work this way in a clockwise or counterclockwise direction, whichever seems easier for you. Follow the procedure as described above for drying, with the addition of temporarily inserting a piece of flexible plastic between the two sides of each folded hinge to prevent it from sticking to itself while drying. This will leave the work of art attached in a manner so that it is not rigidly fixed, retaining some flexibility.

Mounting a Work

If you decide not to mat but to mount your work, you can follow the matting procedure with a few adjustments. If you intend to mount a number of works, it is a good idea to select a standard board size for uniform placement in the storage area. Some artists prefer using a 2-ply board to mount works as a space saving device. This is not recommended since the reduced rigidity will provide only minimal

support. Follow Steps 2, 3, 4, and 5 for making and applying hinges to the work. Next, cut a single mat board to your preferred dimensions. Position your artwork as described in Step 9 and follow the directions in Step 10 for applying the hinges to the board. If you plan to frame the work eventually, you should conceal the hinges by mounting in the same manner as described above for floating a work on paper.

1. Sleeve
2. Double-sided tape
3. Work on paper

FIG. 4.4 POLYETHYLENE SLEEVE FOR WORK ON PAPER

Encapsulation — A Simpler Solution

If any form of mounting or matting seems too compli-
cated or costly, you may opt for a simpler solution.
Encapsulation in a flexible sleeve made from polyester
plastic sheeting, commonly known as Mylar, will
protect the work from direct handling and present it in
a pleasing form for viewing (Figure 4.4).

To make a sleeve, measure the dimensions of the
work and add a 1 inch margin to all sides. Double
these dimensions. Mark the dimensions on the sheet
and cut with a utility knife. Fold the sheet in half.
Using double sided, 1/4 inch width, non-acidic
adhesive tape, apply a strip along each side. Make
sure to place the adhesive tape as close to the edge
as possible. Carefully fold the top sheet over to
adhere firmly. The top of the sleeve will be open for
inserting and removing your work on paper. Once
again, you may want to consider selecting a stan-
dard size for your sleeve if you intend to make and
store many works in this manner. Mylar encapsula-
tion is not recommended for any artwork with a
powdery surface, such as pastel or charcoal drawings.

Chapter 4 Checklist

Matting Materials

❏ 4- or 8-ply mat board
❏ Japanese paper
❏ Rice or wheat starch
❏ Blotters
❏ Gummed linen tape
❏ 1/4 inch double-sided tape
❏ Flexible polyester sheet (Mylar)
❏ Utility knife
❏ Nylon webbing
❏ Short-bristle brush

Matting Guidelines

The rigid support of a mat facilitates protective handling and storage methods for works of art on paper.

❏ For best protection, mount or mat your work to a rigid support
❏ Never use tape, glue, or adhesive on any surface of the work
❏ Mats and mounts should be made only with archival materials
❏ Select 4- or 8-ply mat board for best results
❏ The long, strong fibers of Japanese paper fortify hinges
❏ Mylar sleeves protect works from dust, dirt, and finger prints

5

Framing Works of Art

frame is a more complicated structure than a mat, but logically extends the same protective principles. In addition to protecting the work during handling and storage, an enclosed frame can prevent the intrusion of outside elements, such as dust and dirt, while maintaining a controlled environment. A glazed surface and rigid backing board operate as thermal insulators, and together help to mitigate the harm caused by rapid changes in external temperature and humidity. Both glass and acrylic glazing can be treated with ultraviolet filters to decrease the damaging effects of light.

A work of art should never be placed directly against the glazed surface. Mold and staining will be likely to occur due to contact with the slight condensations of moisture that may accumulate on the inner side. Also, the glazed surface may abrade the image by rubbing against it. A mat prepares a work on paper for framing by creating a necessary breathing space between the artwork and the glazed surface. Glazing is separated from the surfaces of mounted works on paper or works on canvas with

the use of spacers, such as wood fillets or pieces of mat board, that are placed between the invisible underside of the frame and the back board.

When a frame contains the work in an enclosed space it is of utmost importance to use archival materials. A frame insulates a work against hazards, but this very insulation can produce devastating effects if the materials used are acidic. If you have followed the procedures as described in the previous chapter, you will have taken the necessary steps to assure that only archival materials are used in matting works on paper.

The Frame Structure

The frame bears a dual purpose, aesthetic and structural. While the context of this book stresses its protective qualities, its aesthetic features should not be overlooked. The selection of a frame should be carefully considered to determine its effect on the visual appearance of the work. A frame can lend a professional aura to a work or, just as easily, cheapen its appearance. The frame should enhance the ideas expressed by the work of art. Keeping in mind a frame's ability to extend or contain the internal dynamic of the picture will help in making an appropriate aesthetic decision. Collectors may be more concerned with the myriad decorative choices available for framing works. Artists should keep in mind that simple frames are more economical and often enhance rather than detract from the image.

Frames can be custom-made or purchased in standard sizes at art supply stores. Beware of pre-fabricated metal sectional frames which, due to a short lip, do not allow enough space for a rigid backing board. If you buy standard size frames for

your art, but decide to construct your own mats, be certain to measure the mats according to the standard sizes.

The Glazed Surface — Glass or Acrylic?

The glazed surface of a frame can be acrylic or glass. Either one has relative advantages and disadvantages. Glass is cheaper and is far easier to clean than acrylic. Its surface is also more resistant to scratching than an acrylic surface. Glass is often clearer than acrylic but may impart a greenish tint. The major drawback to using glass is its vulnerability to breakage. If a work is to travel often or far, whether or not it should be housed under glass must be carefully considered. However, this factor should not preclude its use for works which will not travel frequently. Methods for packing and protecting glass during travel are discussed in Chapter 8.

Acrylic is often preferred to glass because it is a better thermal insulator. Glass is more sensitive to fluctuations in temperature and humidity, so moisture will condense more easily under glass surfaces than acrylic. For this reason, works framed under glass should be opened up periodically to mitigate condensation tendencies. Glass is also highly reflective, requiring more sophisticated lighting arrangements to prevent glare on the surface. Nonglare glass products are available, but to function properly most require being placed directly against the surface of the work. These products are not recommended for use with works of art. Denglas, a sophisticated nonglare glass product, does not require direct placement against the work, but is also very expensive.

Acrylic sheeting, often referred to by its popular brand name, Plexiglas, is the most suitable type of

glazing for works of art. It is shatterproof, can be treated with an ultraviolet filter at less cost than glass, and is a superior insulator. In addition to its vulnerability to scratching, there are certain restrictions for keeping it clean. Never use glass cleaners, such as Windex, for cleaning Plexiglas. Plexiglas is cleaned by wiping with a mild solution of detergent and water or with a good quality plastic cleaner. When wiping Plexiglas, use an especially soft cloth so as not to scratch the surface.

Plexiglas has a tendency to attract dust to its surface due to its static electric properties, therefore it should never be used to frame pastels, charcoals, or any powdery pigmented surface. When this error is made, you will observe quite quickly that the acrylic will attract loose powdery particles to its surface like a magnet, creating a shadowlike effect on the underside of the glazing. Anti-static polishes that are available from plastics dealers can be used to treat both sides of the surface before framing to diminish static electricity. This treatment will fade over time and should be repeated periodically.

Framing Works on Paper

Along with the matted work and glazed surface, a semi-rigid backing board should be included in the frame package. In addition to providing additional support to the matted work, it shields against the intrusion of dust and dirt and protects the back of the work from punctures. Materials used for a backing board include: foam-cored board, acid-free corrugated cardboard, tempered Masonite, or several layers of 4- or 8-ply mat board. The board should be tailored to fit snugly into the frame against the back of the mat. You can insert a sheet of acid-free paper between the backmat and the backing

board to absorb any lingering acidity. Small nails, thin brass pins, or diamond points are used to hold the backing board in place (Figure 5.1).

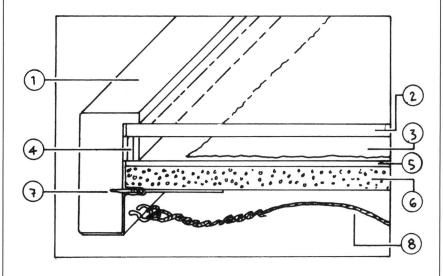

1. Frame
2. Glazing
3. Art
4. Fillet

5. Mat board
6. Backing board
7. Brad
8. Wire and screw-eye

FIG. 5.1 CROSS SECTION OF FRAMED WORK ON PAPER

A strainer, or inner wood frame, is often used as an additional support in framed works on paper. Constructed to the dimensions of the inside of the back of the frame, the strainer should fit snugly on top of the backing board. A strainer is often used when the frame is thin and inadequate to support the glazing, matted work, and backing board. It can also provide a wider surface for attaching hardware. The strainer is fastened to the frame in the same manner as described for fastening the backing

board, and when used will hold the backing board in place (Figure 5.2).

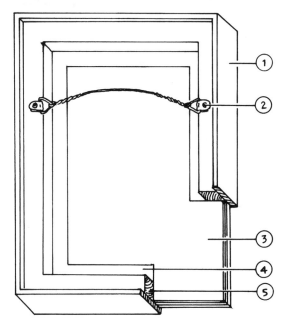

1. Frame
2. Wire attached to mirror hanger
3. Matted work between backing and glazing
4. Dust seal tape
5. Strainer

FIG. 5.2 BACK OF FRAMED WORK ON PAPER

The seam between the backing board or strainer and the frame should be sealed with a permeable archival paper tape. This will prevent dust from entering through the cracks. While the glazing, matted work, backing board, and strainer should be firmly positioned in the frame, the packaging should not be airtight. A permeable tape allows air to enter and enables the materials to adjust to moderate

fluctuations in temperature and humidity. All framed works of art, but particularly those framed behind glass, should be opened every few years to clean any dust or dirt from surfaces and to allow the materials to air.

Alternatives to Framing
There are less expensive ways to protect and encapsulate the matted work without resorting to the cost of a full framing procedure. One recommended method, often referred to as passe-partout, uses pressure sensitive tape to hold the matted work between a glazed film and backing board (Figure 5.3).

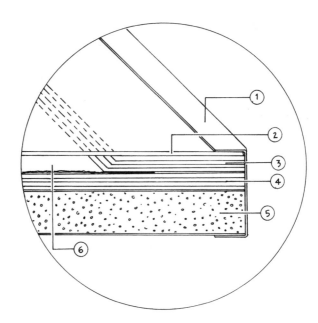

1. Pressure sensitive tape
2. Polyethylene sheet
3. Wlindow mat board

4. Back mat board
5. Foam core board
6. Work of art

FIG. 5.3 PASSE-PARTOUT METHOD OF ENCAPSULATION

The glazed surface can be either a flexible plastic film, such as Mylar, or a more rigid acrylic sheet, such as Plexiglas.

The glazing and backing board should be cut to the same dimensions as your matted work. Place the matted work face up on the backing board and center the glazing over the top of the mat. Using archival tape, wrap around the perimeter to seal all seams, taking care to make neat corners. This method will protect your art for storage, local travel, and display. As with an encapsulation for unmatted works on paper, this method is not recommended for pastels, charcoals, or any powdery surface.

Framing Works on Canvas

It is of utmost importance to ensure that a work on canvas is properly supported by its stretcher before embarking on framing. Unevenly stretched or overstretched works will eventually cause fiber weakening and a rigid frame will only serve to accentuate the stress caused by misalignments. Once the security of the stretcher has been determined, a frame can be employed to protect the work during storage, handling, or viewing.

Frames for paintings are often more elaborately designed than those for works on paper, expressing the physicality of the surface as well as the usually larger dimension. Painting frames may range from the austere to the baroque, but once again it will probably be the collector who is most concerned with decorative choices. Keep in mind that gold leaf or otherwise fragile frames will require just as much surface protection as the work of art itself. Prefabricated painting frames are available at art supply stores. Generally speaking, budget-minded artists may find that in the category of simple frames,

wooden styles give a more professional look to paintings than their equivalently priced metal counterparts. As there are many options available for inexpensive framing, it is worth the effort to do your own comparative investigation to determine the look you want.

Unless a painting is particularly vulnerable or valuable, it is not necessary to frame it under a glazed surface. While increased protection may be assured by placing a painting behind glass or acrylic, the average artist often rejects this method for cost as well as for aesthetic reasons. Keep in mind that a painting whose surface has been carefully protected by varnish will already possess some defenses against environmental dangers. An exposed canvas also enhances the viewer's ability to appreciate the qualities of depth and texture associated with a painted surface, and the distancing caused by a glazed surface often bars access to these details. Housing your work with glassine wrapping and cardboard separators should adequately protect its surface while in storage, and a well constructed frame will prevent damage during handling and viewing.

Strip and Box Frames
A homemade strip, or lathe, frame is among the simplest methods for framing paintings. This method is generally best suited for temporary display or for storage purposes and offers a direct, but limited, form of protection. A strip frame is composed of pre-cut, thin strips of wood tacked to the side of the canvas, forming a protective lip around the perimeter of the work (Figure 5.4).

The length of the strips should correspond to the sides of the canvas, and the width of the wood strips

should be measured to extend marginally on either side of the canvas. The resulting lip will protect both the front and the back during storage and display. By extending the lip in this manner, the edge of the frame is also prevented from abrading the edge of the canvas. This frame creates a simple handle for transporting the work, preventing the accumulation of fingerprint grime on the surface of the canvas.

There are aesthetic and structural drawbacks to strip framing, or to any frame that butts up directly against the edge of the painting. The aesthetic concerns of certain artists extend to include the edge of the canvas, and the strip frame does not allow visual access to the sides of paintings. The strip frame also has undesirable structural features. Its greatest drawback is the method by which it is secured. Nails driven directly into the side of a

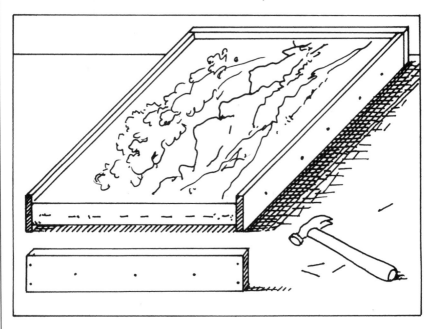

FIG. 5.4 LATHE FRAME FOR WORK ON CANVAS

canvas will abrade the fibers and eventually weaken the support. A better solution that takes these structural and aesthetic concerns into account is a shadow frame, or box frame.

The L-shaped structure of a box frame incorporates the simple advantages of a strip frame, but is less hazardous to the work of art. It is secured to the work with screws that are inserted from the back into the stretcher, thereby preventing structural damage to the support (Figure 5.5). Its recessed facade and comfortable margins allow visual access to the sides of the canvas. Although slightly more complicated than a strip frame, it is still fairly simple and straightforward to construct. With the proper carpentry tools the lip of the frame can be finished to a rounded or soft square edge.

In both strip and box frames care should be taken

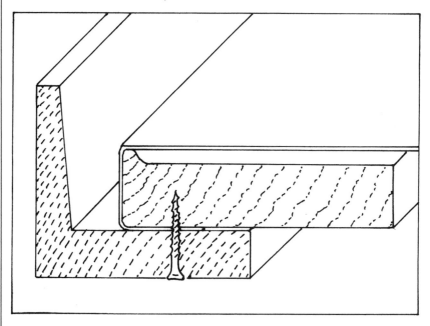

FIG. 5.5 CROSS SECTION OF BOX FRAME FOR WORK ON CANVAS

to protect the back of the canvas. A rigid backing, such as foam-cored board or corrugated cardboard, may be cut to the dimensions of the interior rim of the stretcher, fit snugly into the recessed area, and attached to the crossbars with screws. This protective backing will act as a dust cover and deterrent to punctures from the back of the canvas. Metal plates, which are screwed into the frame, will assist in supporting the painting in the frame structure (Fig.5.6).

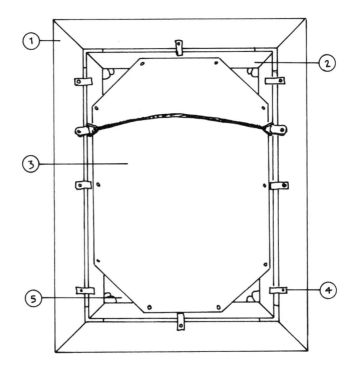

1. Frame
2. Painting stretcher
3. Back board
4. Metal plates
5. Cut corners allow for air circulation

FIG. 5.6 BACK OF FRAMED WORK ON CANVAS

Plexiglas Box Constructions

Mixed media, collage, and relief surfaces constitute a particular category of two-dimensional art. Since the surfaces of these works tend to be fragile and also prone to dirt and dust accumulation, they may be best protected by enclosure in a Plexiglas box construction. This method is advantageous because such a box can be constructed to accommodate the depth of the relief elements. A box construction can be adapted to house vulnerable sculptural objects, simply by shifting its orientation from vertical to horizonal (Figure 5.7).

To create a Plexiglas box for two-dimensional works, a 3/4 inch wood back board cut to the exact dimensions of your stretcher should be secured to the stretcher with screws. If you do not have the necessary tools or skills to create a Plexiglas cover, a local carpenter can make one to your specifications. The Plexiglas top should be constructed to fit snugly over the support. When aligned with the edges of the back board, mark screw hole locations accurately on both surfaces. Drill holes carefully so as not to create excessive vibrations.

Most sculptors consider the base to be an integral part of the their sculpture. However, objects that are made to be displayed openly on a pedestal or shelf may be temporarily or permanently protected for storage, exhibition, and local travel by enclosure in a Plexiglas box. Unlike a wall relief, a freestanding sculpture has no predetermined support dimensions and therefore the size of the box can vary according to your aesthetic preference. The base and box dimensions should enhance the appearance of the object. Too small a space will make the sculpture appear cramped and too large a space may make it appear dwarfed. These perceptual considerations,

A-Vertical
B-Horizontal

FIG. 5.7 CLEAR ACRYLIC BOX CONSTRUCTIONS

of course, would be best made by the artist.

For maximum security, the sculpture can be secured temporarily or permanently to the baseboard by whatever means is suitable to the material. Artists should be able to determine the best method for securing their own work, but collectors should consult the artist or a conservator for professional advice before taking this step. You may decide you do not want to secure the work, either for aesthetic or structural reasons. In this case, be absolutely certain to let anyone who handles the box know that the object contained within is not secured.

Hardware

The basic rule for hardware is to select wire and hooks which are the proper strength to support the work of art. Picture hanging hardware comes in many varieties. Hanging devices made of metal loops attached to plates are the preferred choice of professionals, and are particularly recommended for paintings. They are strong, secure, and can be used to support the picture by hanging wire, or, alternately, by attaching the hoops directly to wall hooks. Small, lightweight works, as a case in point, are often more secure when the hoops are attached directly to wall hooks rather than strung with wire. If the work swings freely from the wall when touched it is probably not heavy enough and should be secured directly to the wall. Hanging plates should be attached to the back of the picture at a point approximately one third down from the top of the frame. Make certain that the length of the screw is calculated so that it will secure the hardware but not risk puncturing the front of the work.

Screw eyes can also be recommended for hanging works of art, especially smaller works which do not

provide an ample surface for applying the plate variety.

Screw eyes should be applied to the inner side of the frame, stretcher, or strainer, so that they do not protrude from the back of the frame (Figure 5.1). Gummed and self-adhesive hooks are another variety of picture hangers. They are only to be used cautiously and with very lightweight works of art.

Picture wire should be stretched taut between the two loops, with just a little bit of give. Knot and twist the ends of the wire for better security and to prevent a ragged edge from harming you or your artwork. A piece of tape wrapped around the joined area will provide additional protection. Two picture hooks placed some distance apart on the wall are recommended for hanging works of art. This method is more secure than a single hook and will help keep the work level.

Bumpers, made from small pieces of cork or rubber, may be glued to the back corners of the frame to cushion the work against accidental jolts and bumps. They will also protect the work from coming into contact with walls. This is particularly important if the work is installed on an exterior wall that might fluctuate in temperature and dampness. Bumpers also ensure proper air circulation behind the work.

Chapter 5 Checklist

Framing Materials

- ❏ Ultraviolet-treated glass or acrylic glazing
- ❏ Acrylic film or sheeting (Mylar or Plexiglas)
- ❏ Rigid backing board (foam-cored board, corrugated cardboard, tempered Masonite, mat board)
- ❏ Plywood
- ❏ Pressure-sensitive tape and paper tape
- ❏ Anti-static polish and acrylic cleaner
- ❏ Small nails, brass pins, or diamond points
- ❏ Screws
- ❏ Metal plates
- ❏ Hanging wire
- ❏ Picture hangers
- ❏ Cork or rubber bumpers

Framing Works of Art on Paper

- ❏ Powdery surfaces should be framed only under glass
- ❏ Use ultraviolet filtered glazing to protect against fading
- ❏ Use permeable materials for controlled air circulation in the frame package

Framing Works on Canvas

- ❏ Make sure that the work is stretched properly
- ❏ A box frame provides aesthetic and structural advantages
- ❏ A backing board protects the painting against puncturing
- ❏ Acrylic boxes provide protection for paintings with relief surfaces and vulnerable sculptural objects

Hardware

❏ Select hardware relative to the weight of an object
❏ Paintings are best supported with metal-looped plates applied one third of the way down from the top
❏ Secure small works by attaching directly to wall hooks
❏ Secure the joined ends of hanging wire with tape
❏ Hang paintings from two wall hooks for maximum security
❏ Bumpers keep paintings from direct contact with the wall

6

Documenting Your Inventory

Keeping track of your art by noting its placement, condition, and travel history is a good habit to form. A record keeping system will assist with your own studio organization, and together with photographs of your work, will form a core of documentation to support future curatorial questions, tax inquiries, and insurance matters. This chapter will outline systems for keeping track of inventory, and suggest guidelines for noting the condition of your work. Chapter 7 will describe how to photograph work in your studio.

While of utmost business importance for the artist, this chapter will be of particular relevance to the collector or art dealer. Guidelines for developing a custom designed record keeping system are included for the use of both. Collectors and art dealers should note the specific advantages offered by computers, in particular the flexibility this method of record keeping will allow in producing the type of documents needed to maintain a collection properly. See Chapter 12.

Collectors and art dealers not only need to be informed about the work they own or handle for

their own business purposes, but also bear a responsibility to the artist for relaying accurate information about each work, including how it was made, where it has been shown and what, if any, vulnerabilities it has. Collectors will also, no doubt, be concerned about the safety of their art when on loan. The best measure for assuring its well-being is to be informed about its physical properties in advance, and to share this concern with the borrower. The care of art, in an ideal sense, is a collaborative process that extends beyond the studio of the artist, with the collector, dealer and curator acting in accord with the best interests of the artist and the work.

Another important aspect of record keeping is its relevance to tax and insurance status. Artists are sometimes challenged by the Internal Revenue Service as being "hobbyists" who should not deduct losses on Schedule C. Accurate inventory records are important to prove validity as a business. (For a full discussion of the hobby loss issue, see *Legal Guide for the Visual Artist* by Tad Crawford, Allworth Press). However, for tax purposes, inventory records should be considered only as a supplement to a separate financial ledger that documents income and expenses. In this ledger you should be assiduously recording all expenses relating to your studio and work, with back-up documentation, in a chronological format. This kind of accurate information about your work and studio will also be essential if an insurance claim has to be made.

Categorizing Inventory

Every work of art should receive an inventory number. This number might reflect the manner in which the studio or collection is organized and

stored. As mentioned in Chapter 3, arranging works according to their type will lessen the risk of damage by assuring that objects in storage units are physically compatible. Vulnerable works on paper are best separated from heavier, or framed, paintings. Two-dimensional works of art should not be stored near three-dimensional constructions. Organization by type will also facilitate record keeping.

A simple method for establishing an inventory system is to assign a letter for each medium (for example, P for painting, D for drawing, and S for sculpture) and a number to each work in that category. A simple and logical numbering system would be to first indicate the type, followed by the year and then the sequence of production, or acquisition, within that year. For accuracy and consistency, inventory numbers should be notated within a field of 999 potential entries. For example, drawings acquired or created in 1990, might be numbered D90.001, D90.002, D90.003, etc. A second, more specific, categorization system might indicate month and day of completion, such as D90.01.09.01, D90.01.09.02, etc. (indicating respectively, medium, year, month, day, and daily chronology.) Both of these systems are useful because they codify curatorial information about the work.

Standardizing the inventory number in this manner will help to keep the format consistent and is especially important if you are computerizing your records. A standardized inventory number, like a seven digit phone number, will let you know automatically if any digits have been lost. Lost or illegible digits are often a problem with older works, where inventory numbers have faded from light exposure or have rubbed off through handling.

Artists working in multiple forms or in series should take care that the inventory number indicates that a work is comprised of parts, such as a triptych or diptych, or is one of a series, as in a print edition. You can assign a small letter after the inventory number to categorize these types of work further. An inventory number such as P90.010.a-c would indicate that the painting was comprised of three parts.

Noting the inventory number on the work of art will facilitate record keeping. Especially as time goes by and work accumulates, reference to an inventory number will offer a foolproof means of matching work to your records, rather than relying on the title and date of a work to match with the inventory record. That being said, a collector should avoid directly writing on or marking works of art as this may be perceived as disfiguring the object. Alternative methods for direct marking include writing on the inside of a mat or folder for work on paper, tagging the back of stretchers for paintings, and tagging the underside of the base for sculpture. For the artist, marking directly onto the work is a personal and aesthetic decision. Artists may not want categorical information to appear visibly alongside the signature, date, and/or title. It is appropriate for artists to record the inventory number on the back of the work with the following considerations. Works on paper should never be marked with anything other than a medium weight lead pencil. Paintings may be marked only with indelible markers that have a soft point. Documentation made by a hard point on the back of the canvas may lead to cracks and actual surfacing of the notation on the front over time. Sculpture, depending on the material, may have the number etched, carved, or written in an indelible ink on the base.

Computer and Manual Systems for Record Keeping

Once you have established a way to identify inventory, you should establish a system for centralizing all information pertinent to each work. This may be done by log, card file, or by computer. It is quite easy to create forms customized to your needs and have them typeset so that copies can be made. Loose-leaf binders, one for each category of art, can be used to house these standardized forms. File cards designed for the purpose of documenting art are commercially available through William Soghor, a New York based supplier.

Maria Reidelbach, a private registrar based in New York City, advises artists and collectors on how to organize their collections. Computerization is one of her specialties. She recommends the use of computers for their economy in managing information. "The beauty of using a computer data base manager is that you enter the information and proof it once, and it can then be printed in a variety of forms." Ms. Reidelbach advises that a basic entry layout be used to record all information pertinent to the work of art. For an artist, this might include sales records, travel history, and bibliographic information. For a collector, this could include purchase price, appraisal history, storage location, and provenance of the work. By programming the data base, the computer can be formatted to retrieve selected information from the basic entry layout and recast it for such diverse and specific needs as appraisal forms, slide labels, and insurance lists (Figures 5.1-3) Always keep a duplicate disk of your inventory in a safe place to safeguard against theft or damage.

For a more detailed discussion, see Chapter 12, "Using Computers to Help Care for Your Art," written by Ms. Reidelbach.

Artist: Mary Painter
Date of entry: 6/28/90 cat. #: D90.069
Gallery #: 8
Title: Self Portrait
Year: 1990
Medium (and edition #): oil on paper
Size: 15 x 20 x (h x w x d)
Present location: Smith Collection, 1990
Photos:

 b/w: X slides: X **8x10:** **4x5:** X
 ☐ ☐ ☐ ☐

Questions: _____
Purchaser, date: John Smith, New York, NY, 1990
Sale price: 5,000.00
 Discount: 10%
 Actual price: 4,500.00
 Split: 50%
 Amount due: 2,250.00
 Amount received: _____

EXHIBITIONS: *(year institution, location, "title," <cat. il.>dates)* 1990 Doe Gallery, New York, NY, "Recent Paintings," <cat. b/w il.> 3/15-4/15. **BIBLIOGRAPHY:** *(Author. "title," SOURCE, il. p. date, v.n.)* Pincenez, Jane. "Down the Tubes," ART REVIEW MAGAZINE, p. 17, May 1990.
COMMENTS: Signed and dated on verso
Self Portrait 1990

FIG 6.1 BASIC ENTRY LAYOUT © Maria Reidelbach

Oil on paper 15 x 20
Smith Collection, 1990

purchaser: John Smith, 1990 sale price: 5,000.00
dealer: Doe Gallery
amount received: _____
photos: b/w: ___ slides: ____ 8x10: ____ 4x5: ____

Exhibitions: 1990 Doe Gallery, New York, NY,
 "Recent Paintings," (cat. b&w il.) 3/15 - 4/10.
Bibliography: Pincenez, Jane. "Down the Tubes,"
 ART REVIEW MAGAZINE, p. 17, May 1990.
Comments: Signed and dated on verso.

FIG. 6.2 FORMAT FOR 5 BY 8 INCH FILE CARDS

MARY PAINTER #D90.069
Self Portrait 1990
oil on paper 15 x 20"

FIG. 6.3 FORMAT FOR SLIDE LABELS

Categories of Information

Whether you choose a manual or computer system for your record keeping, there are four main categories of information that should be maintained about each work. These categories correspond to its technical composition, condition, location, and curatorial history. Initially, documentation of a work is done primarily by the artist, but ideally the information should be passed along to subsequent caretakers. For future safekeeping of a work of art, this point cannot be stressed highly enough. Many museums have now instituted policies of querying the artist when acquiring his or her work. Forms requesting the categorical information described above are routinely sent to artists and kept on file for curatorial and conservation purposes. However, artists can facilitate this process for museums and collectors by including documentation with their work when it leaves their possession. This documentation may record the materials used, the method by which it was constructed, and any particular aesthetic concerns the artist may have regarding its presentation.

New interpretations of the aesthetic boundaries for works of art have become an increasingly important, and sometimes contentious, issue in contemporary art. Marcel Duchamp's famous glass piece represents a certain conceptual point of view about integrating the aging process of materials into the work of art. Other artists, however, may determine that a work becomes invalidated if it does not retain its original appearance or reflect the artist's stated intention. Interpretation of disfigurement can be highly subjective and an artist can prevent later complications by stating his or her point of view about these issues in advance.

Recording Technical Information

Artists should always record the exact materials used in their work. Record all particularities, such as the name of a product and the company that produced it. Information regarding the construction of the work is also of great importance. If it is a painting, identify the nature of the support and how it was prepared prior to working on it. Was the surface treated by a varnish after completion? If it is a sculpture, indicate what material was used. Details such as whether marble is of domestic or foreign origin may later be relevant. If the work was assembled, describe how the parts were secured and whether you used a binder, such as glue. All of this information not only helps in describing the work, but is invaluable later if the work needs to be treated or repaired. Often conservators face ethical issues when they are forced to guess what materials an artist used. Whether or not they feel they are restoring a work to its authentic former state depends in good part upon access to this information.

Curatorial Records

Most artists are only too happy to record that a work has been exhibited or reviewed, and documenting curatorial information seldom must be urged on them. In addition to any catalogues, reviews, or publicity materials, checklists noting all works in an exhibition should be maintained for your records. This holds true for group exhibitions as well as one-person shows. Knowing what work appeared along with yours may help a curator or scholar understand your work in a broader context. Publication materials should be organized by category, such as catalogues, articles, reviews, and arranged chronologically. Collectors may prefer to organize exhibition

catalogues and biographical material by artist.

Tracking Destinations

Keeping track of your artworks' locations can be a chore and may include hidden headaches, but for reasons of control and safety this step should be well managed. Most artists, at least theoretically, would like to know where their work is at all times, and under what conditions. If you are managing your own work, record its temporary destination and the conditions under which it is being lent. If a work is sold, record the name and address of the individual, group, or museum which purchases it. This information may be useful for your own marketing purposes, as many artists like to send their collectors updates on current exhibitions, recent publications or relevant personal news, such as awards or fellowships.

Your use of business and legal forms assure that you and your art are protected when a work leaves the studio, so the use of such forms is highly recommended. Artists may refer to *Business and Legal Forms for Fine Artists* by Tad Crawford (Allworth Press), which includes contracts for the sale, receipt, and consignment of works of art. If your work is being handled by a dealer, you should agree on these terms in advance. More information about insurance liabilities and the security of your art will be presented in Chapters 10 and 11.

Sometimes a work of art will pass from one collector to another, or from a collector to a public collection. The transaction may occur directly, but it often involves the intervention of a dealer or auction house. Secondary turnover of artwork occurs more commonly with the work of well established artists, but any artist will want to be

aware of the fact that a work has changed hands. Keeping track of the location of your work under these circumstances may be difficult. If you are represented by a dealer, ask him or her to intercede in obtaining information about the current owner. If you are self-managed, there are polite ways to request this information. You may ask to be informed by the original owners if and when the work leaves their collection, and to whom it goes. If a work appears at auction, you can request that the auction house forward a letter to the buyer. As a courtesy, museums often inform artists if their work has been acquired for the permanent collection and, if permitted by the donor, will reveal the terms of the acquisition, such as whether it was acquired through purchase or donation. The artist, of course, will want to use this information to update his or her resume.

Documenting Condition

This leads us to the final category of documentation, that concerning the condition of the work of art. This information is related to all categories that precede it. Whether its purpose is monitoring the health of artwork in your home, gallery, or studio, instructing borrowers in the intelligent handling of art objects, having the proper back-up for insurance claims, or advising collectors or museums in the proper care, display, and appearance of your work, documenting its condition is essential.

In our discussion on materials in Chapter 2, we stated that the condition of a work may be affected by inherent vice or by external factors, such as the environment or improper handling. Making a periodic check of your works' condition will help you to know whether any noticeable deterioration

is related to intrinsic or extrinsic factors. Often distinguishing between the two is hard to determine due to a cause and effect reaction. This is all the more reason for artists to document the vulnerabilities of their work as a preventive measure.

While the artist is not expected to have the training of a conservator, there are definitions commonly used by professionals for noting the condition of a work. These will help in guiding observation and will facilitate a more objective means of comparison. The objectivity of a condition report is based on the assumption of a common ground in perception and standards by the parties concerned. Artists can be guided by museum publications to help in identifying condition standards, but even among professionals there will be differences in nuance and point of view. To narrow these differences, artists should develop some technical awareness to render their condition reports consistent with outside professional standards.

Museum professionals often note the condition of artwork according to three different considerations. Condition reports on a work may be subdivided into observations regarding damages, insecurities, and disfigurement. Damage is defined as any permanent alteration or structural change to the work as a result of mishandling or environmental factors. The work's insecurities are the presence or potential for inherent vice or structural weaknesses. Disfigurement is a result of alteration in concept or design, such as the darkening of varnish, change in patina, or misinterpretation of placement or installation.

Routine terminology has been established to refine these general classifications. Such terminology has become increasingly sophisticated, reflecting advances in conservation technology. However,

terms such as abrasion, grime, cleavage, paint loss, weakness, brittleness, and dullness are among those commonly used to describe visual appearance, and such adjectives as negligible, slight, moderate, marked, and extreme, are useful for describing the degree of the specific condition. Readers who would like to familiarize themselves with these terms are referred to the technical glossaries prepared for art professionals in Conservation Standards for Works of Art in Transit and on Exhibition by Nathan Stolow, published by UNESCO, or to the section titled "Inspecting and Describing the Condition of Art Objects" by Richard D. Buck in Museum Registration Methods, published by the American Association of Museums. These glossaries contain descriptive definitions of conditions relating to all forms of art, including paintings, drawings, and sculptures.

Examination of your work in the studio should be done periodically. Keeping condition records of all works of art at consistent intervals while in storage will reveal whether they are gradually deteriorating. From this information you may be able to infer whether this is caused by inherent vice or whether storage conditions are not satisfactory for the physical properties of your work. Necessary adjustments in the use of your materials or in the environmental conditions of your studio, such as temperature, humidity or light levels, can be made accordingly.

A work should always be examined and its condition recorded before it leaves the studio and again when it is returned. This form of documentation will help in detecting any changes that may have resulted from environmental changes or mishandling. If an insurance claim needs to be made as a result of damage that occurs off the

premises, the presentation of such a document will provide important evidence.

The easiest form of visual documentation, but not the most effective, is taking a Polaroid of the work. This is certainly better than nothing for crude comparative purposes, but may not adequately reveal any fine points of alteration. A better system for documenting your art involves the use of a black and white photograph along with a written description of the work.

A complete physical description of the work should be noted on a form, including its identifying information (title, date, medium), its physical dimensions, weight, any supplementary parts (frame, base, etc.), the environmental conditions of the studio, and a description of the work's surface. The best method to use for gaining an impression of any surface irregularities is to use a strong light to illuminate the work from one side at a 45 degree angle to the plane of the surface. From this vantage point, if it is lit uniformly and is free of glare, surface blemishes and irregularities, particularly minor cracks, crevices, cleavages, and discoloration, will be highlighted. Changing the orientation of the light may help in uncovering additional surface features.

Documentation of surface features, their exact locations, and measurements, can be recorded directly onto the black and white photograph, but a transparent overlay is a better method. Accuracy will be facilitated by marking the overlay into quadrants or nine sections. In this manner, surface defects can be described and referred to by zone. As the work ages, the overlay may be transferred onto more current photographs to look for evidence of gradual deterioration and new surface features.

Chapter 6 Checklist

Documenting Your Inventory

Keeping track of your art by noting its placement, condition, and travel history is a good habit to form.

❑ An inventory numbering system is important for accurate record keeping

❑ Record keeping systems should record technical, curatorial, and financial information about the work of art

❑ Computer data base systems manage information economically

❑ Pass information on to collectors and museums to assure proper care for a work of art

❑ Check the condition of your art at regular intervals

❑ Organized inventory records are essential for legal and business purposes

7

Photographing Your Work

A camera is a very useful tool to own. You should have one in the studio to record works for technical and business documentation. For these purposes, a Polaroid camera will do; however, a 35-mm single lens reflex camera can be used for a greater variety of purposes. High on this list is the ability to take slides of your own work. Artists are continually called upon to submit visual material for use in evaluation of their work. The quality of the slide is of paramount importance in making a good first impression. Controlling the quality of your slides and cutting costs are persuasive reasons for learning how to photograph work in your own studio.

The following discussion will give basic instructions for shooting two-dimensional works of art in the studio.

Equipment

The following equipment will be needed for shooting work in your studio: 1) Single lens reflex 35-mm camera, 2) tripod, 3) cable release, 4) hand-held light meter, 5) tungsten lights, 6) light stands, 7) a gray card, 8) film, 9) a data notebook.

Single lens reflex camera. You should invest in a good quality single lens reflex 35-mm camera with adjustable aperture and shutter speed. A normal 50-mm length lens will be adequate for most purposes, but a long or macro lens may be required for photographing miniature work, or for gaining close-up details of larger works.

Tripod. A three section, braced leg, adjustable tripod, with non-skid feet, is the recommended standard variety. Check to see that it is stable and easy to adjust.

Cable release. A cable release screws into the shutter release button and is recommended for eliminating camera movement.

Light meter. Some artists consider the use of a hand-held light meter an optional feature, preferring to rely on the camera's own built in meter. However, a spot meter, or other types of hand-held meters, used with a gray card will ensure a uniformly lit surface and provide best results.

Lights. Two Tungsten lamps, 3200 K, can be purchased in most photo supply stores.

Light stands. Commercial tripod light stands can be purchased in photo supply stores, but this expenditure can be avoided by improvising with what is at hand. Lamps can be clamped to chairs, to broom handles anchored by cement in paint cans, or to home-made adjustable stands.

Gray card. An 18 percent gray card is used with a spot meter to register unevenly lit areas. It is also

useful for registering variable light readings on the surface of a high contrast composition, the average of which will help to calculate a precise meter setting.

Film. The use of moderate to low speed color slide film is recommended.

Notebook. A small notebook for data recording.

Setting Up Studio, Camera, and Object

While some artists proclaim the virtues of daylight for illuminating work when shooting slides, a larger consensus selects a darkened room for greater control. Shooting at night is optimal for this choice, but you can always block out window light during the day with dark paper or shades. Even if you are shooting at night, be aware of strong outside illumination, such as nearby streetlights, or neon signs, and their potential for creating an imbalance in your light settings.

Prepare your working wall by painting it or covering it with a neutral backdrop, made from cloth or paper. Some artists prefer to use a white backdrop to simulate the appearance of a work on exhibition in a gallery. Others prefer the use of black for greater visual contrast and because it tends to absorb rather than deflect light. Black is often the preferred backdrop when the image is to be projected, as in a slide lecture. It may also help to eliminate the need for masking out areas around the object.

Set up your camera on the tripod facing the working wall at a comfortable viewing height. It should be placed at such a distance that the image of the work fills the viewfinder of the camera. Paintings may be hung from a nail or placed on an easel painted the same color as the backdrop.

Unmatted works on paper can be held in place with thumbtacks or pushpins. To avoid making holes in the work, use the tack or pin to clamp the edge rather than to puncture it. For best results, works should be shot unframed. Photographing works under glass is not recommended since elimination of glare requires special filters and techniques.

Measure the height of the center of the lens and hang your work on the backdrop with the center at the same height. Use a tape measure and level for accuracy. The more exact the parallel and right angle relationships are between the work and the lens, the less potential for distortion and misalignment in the image.

Setting Up Lights

Set up your lights from both sides at a 35-45 degree angle to the surface of the work, depending on the level of glare, and at a distance of a minimum of several feet from the wall (Figure 7.1). They should be positioned at the same height as the lens and the center of your art (Figure 7.2). Direct the lights so that they cover the surface evenly, with the pools of light overlapping (Figure 7.3).

As you make adjustments to the lights, keep in mind that they are very strong and have a relatively short life span. The intense light will create heat, which has already been noted as an undesirable condition for a work of art. Although a necessary evil in taking photographs, you should avoid over-exposing your work to the light. Turn the lights on sparingly and try to make your adjustments quickly. Always keep replacement lights on hand to avoid work interruptions.

Adjusting the lights so that the surface is evenly

FIG. 7.1 POSITIONING LIGHTS AND CAMERA AT CORRECT ANGLES

FIG. 7.2 CENTERING CAMERA AND LIGHTS FOR SHOOTING A WORK

**FIG. 7.3 OVERLAP POOLS OF LIGHT FOR OPTIMUM
BALANCE**

illuminated takes practice. Your objective is to try
to eliminate all visual hot spots and dark patches,
imbalance, and glare. These can be eliminated by
moving the lights closer or further away, or by
tilting the shades up or down. Holding a pencil or
a card at a right angle to the work and comparing
the shadow cast on either side will tell you whether
the opposing lights are striking the surface evenly.
If the shadows do not appear identical, adjust the
lights until they are of equal strength. Try moving
the lights toward the wall if glare is reflected from a
varnished surface.

Using the Hand-Held Light Meter

Once you have balanced the lights by sight, the gray card and a spot meter may be used to gain further precision. If, for example, the work is painted in an overall medium tone, spot readings taken with a gray card can reveal subtle imbalances in surface lighting. For a work with strong contrast, the gray card can be used to calculate an appropriate meter setting. Readings taken from dark and light areas of the composition will give you a high and low, from which an average range can be calculated. This type of information often cannot be gained from the camera's built-in meter and can make a difference in achieving a professional look.

A spot meter is used by focusing in on the gray card positioned close to and parallel with the surface. Readings should be taken at regular intervals across the surface of the object. Adjust the lights and continue to compare your meter readings until the surface is lit uniformly. After all adjustments have been made, the final meter reading or the average of a high and low reading will be used to select the camera setting.

A meter reading gives you a figure, but does not tell you exactly how to set the camera. There will always be several possibilities for setting the aperture opening, or F stop, in relation to the shutter speed to match the meter setting. The variations can be used to gain different effects. For example, the smaller the F stop, the greater the depth of focus. This choice may be useful for highlighting surface details on works with relief elements.

Test Shots and Bracketing

If you are a novice, it is strongly suggested that you shoot a test roll and have it processed before proceeding. Document the test shoot in detail by recording the light reading, aperture setting, and shutter speed. Keep the lights set up in the same position so that you can make corrections from the test roll. All artists, beginners or otherwise, should record this data for future reference. You will greatly improve the ease of your next shoot by committing this information to paper, rather than to memory. Over time, and through trial and error, your efforts will eventually result in more consistent results, but be prepared for mistakes to be made in the meantime.

Many artists shoot each work in multiples, either by bracketing (shooting 1/2 F stop higher and 1/2 F stop lower than the calculated setting), or by shooting three to five times at the same setting. Bracketing is recommended because, despite your meter calculations, you may find that you visually prefer the result of a slightly higher or lower aperture setting. Shooting in multiples also provides you with duplicate slides for professional use or for documentary purposes.

Filters

To achieve the most accurate color renditions, you may need to use a filter. Filters are used to compensate for the relative warmth or coolness inherent to different types of film, or to make an emphasis in the tonality of light. For example, an amber filter can be used to suggest the warmth of day light, or a blue filter to suggest the coolness of artificial light. Distinguishing these variables requires a certain level of sophistication and it is recommended that

you shoot straight film first to develop your eye. Later, you may want to consult with professional photo suppliers who can advise you as to the best combination of film and filter to suit your particular needs. Remember that even the best color renditions may only be able to achieve a close approximation of the actual work.

Three-Dimensional Works of Art

The technical knowledge, equipment, and level of expertise involved in photographing three-dimensional works are far greater than those required for two-dimensional works. A flat surface does not pose the same degree of variability that a volumetric object does. Cast shadows, degree of contrast, and angle of orientation, are all conditions which require an expert eye and more elaborate instructions than this book can provide. For artists who would like to learn these techniques, a good reference is *How to Photograph Works of Art* by Sheldon Collins which is listed in the bibliography.

Chapter 7 Checklist

Photographing Works of Art
Artists can learn to take good quality slides of work in the studio and cut costs considerably.

❑ Novices should shoot a test roll first for practice
❑ Position angle of lights and camera accurately
❑ Make sure light is evenly distributed over surfaces
❑ Record camera and light settings in a data notebook
❑ Avoid shooting works of art under glass
❑ Use lights sparingly to avoid overheating works of art
❑ Filters may be used to adjust background

8

Preparing Your Art for Travel

Transporting artworks safely involves the consideration of factors that may affect your art outside of the protective environment of your home, studio, or display area. Even if you have observed all of the recommended safeguards for handling, storage, and display, moving a work of art requires confronting risks that are often beyond your control. Of course, works of art are constantly being moved all over the world and, when properly packed, usually arrive in good condition. You can anticipate and control risks by knowing how to pack art properly and by choosing an appropriate mode of transportation. Learning and applying certain principles will ensure that your work is protected and handled properly when it is no longer under your surveillance.

Requests for loan exhibitions, consignments to galleries, or sales, all dictate that a work must travel.

Should your work of art travel and under what circumstances are the first questions you should ask yourself. The physical characteristics of the object, its destination, and the means of transportation available should all be examined in order to determine how best to pack the object for maximum protection. All of these factors must be considered with reference to your budget. How much of the process you want to handle yourself will also have an effect on the expense. Professional art transporters can be hired to wrap, pack, and crate your art, but these steps can also be accomplished by you in your own studio or home.

Imagine a work must travel from the humid summer climate of the East Coast to the parched summer heat of Southern California. Or, you have hired a van to drive a body of work to an exhibition during inclement winter weather. You will want to ensure that your work is cushioned against excessive travel vibrations or traumatic shock, insulated against fluctuations in temperature and humidity, and protected from water and other types of spills. Waterproofing, insulation, and padding in packing and crating are key factors for assuring full protection to works of art during transit.

Condition Check

Determining whether your work is suitable for travel is a critical first step. If the object is exceedingly fragile or vulnerable, try to be objective and calculate the risks it will endure against the necessity of its transit. If the risks outweigh the reasons for its travel, the prudent choice is to keep it in one place. Weak, fragile, or unstable objects are particularly prone to damage from movement and handling. If a

work in this condition must travel, it is advisable to consult with a specialist for specific advice on wrapping and the best means of transportation.

Once you have made the decision to let a work of art travel, take the time to assess its condition and record any weaknesses or prior damages on a condition report. A copy of this should be dated and inserted in the travel package to serve as a guide to the person unpacking the work. It will also serve as an essential document in the event any new damage occurs. Diagrams or photographs will also be helpful to the person who unpacks the work, particularly if the work must be reassembled or its orientation is unclear. Before wrapping, make sure that all component parts, including frame, backing board, and base, are secure. Remove all hanging devices, or secure them in a way that presents no risk to the work itself, or to other works included in the package. Proper documentation and securing the object are essential precautionary steps.

Proper Wrapping Methods

In previous chapters the importance of using acid-free materials for storage and presentation has been stressed. Concern for the use of archival quality materials extends to the selection of appropriate protective materials for packing. At no time will the risk of damage be greater than during transportation, so packing materials must be selected wisely. Even under the most controlled travel situations weather fluctuations and movement are bound to exceed the relative stability of storage and display areas. Proper packing materials can help to reduce these stresses on your art.

The objective of proper wrapping is to keep the

object free of dust and dirt, to pad it, and to protect it from water and spills. It is recommended that your work be covered first in a wrapping of soft, acid-free, moisture-absorbent material, such as glassine or tissue paper. This wrapping will keep the work clean and absorb any condensation that may form due to fluctuations in temperature and humidity. A secondary plastic wrapping will shield the work in the event of accidental flooding or spills. Remember that at the same time that plastic wrapping shields water from the outside, it can also act to trap moisture on the inside. As a general rule, the waterproofing shield should only be used in conjunction with a primary layer of moisture-absorbent material to counteract this tendency.

Although artists commonly wrap art only with plastic sheeting, there are reasons to avoid this. In addition to promoting condensation, plastic sheeting can become charged with static electricity and, as a result, attract dust and dirt to the work's surface. Never use plastic to wrap unframed works of art on paper with powdery pigments, such as pastels. The tendency of media like these to flake will be aggravated by the static electric charge of the plastic. Plastic wrapping also has the potential to fuse with varnish and acrylic paint surfaces under high temperatures and humidity, so take care to wrap paintings with glassine before wrapping in plastic, and, of course, avoid exposing them to any environmental extremes.

Packing materials should be used to pad and protect objects against the bumps and jolts associated with handling and travel. Products made of polyethylene foam, such as Ethafoam, provide state-of-the-art, anti-static, protective padding. Ethafoam can be purchased in flexible sheeting and in semi-

rigid blocks. Bubble wrap is another popular form of protective wrapping. The virtues of both these materials are that they combine a waterproof barrier with padded protection. Care should be taken to wrap objects with the bubble side facing out to minimize the risk of imprinting a bubble impression on the surface of the object. The vulnerable corners of unframed and framed paintings should be protected during transit with strips of felt or padded paper that are cut to fit snugly over the primary wrapping.

Unframed works on paper should be wrapped individually in acid-free tissue or glassine and housed together in a rigid portfolio. Fiberboard or foam-cored board are suitable materials for forming a protective package. A well-constructed portfolio can be used to carry small packages by hand, such as in the city, or for local transit in a car (Figure 8.1). For greatest safety, observe the storage rule for keeping similar size works together when packaging multiple works on paper.

Works that are framed behind glass are always risky to transport. Whenever possible, either replace the glass with Plexiglas, or dismantle the frame package and wrap the glass carefully in a separate, padded wrapping. When neither of these options is possible, a masking tape gridwork should be applied to the glass. Taping will not strengthen the glass, but it will hold jagged pieces together and away from the surface of the work in the event of breakage. Tape should be applied in a crisscross pattern on the surface of the glass with the end of the tape turned in on itself to form a flap for easy removal. When removing tape, pull back so the tape remains as close to the surface as possible, rather than pulling upward at a ninety degree angle.

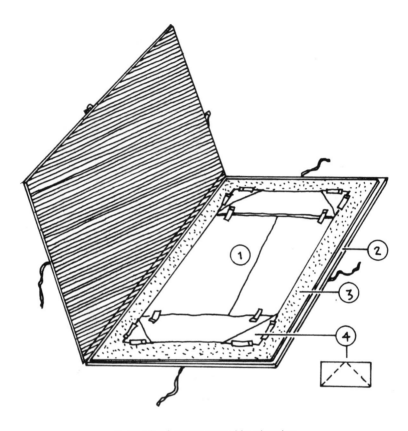

1. Work of art wrapped in glassine
2. Portfolio
3. Rigid support
4. Paper corners secured to board with tape

FIG. 8.1 SECURING WORKS ON PAPER INSIDE A PORTFOLIO

This will prevent unnecessary stress to the glass. Extra care should be taken to pad and cushion works behind glass. Plexiglas should not be taped as adhesive is extremely difficult to remove from its surface.

In general, artwork should be wrapped simply and without excessive taping. Never tape directly to the work, its frame or its base. A primary wrapping of moisture-absorbent material, followed by a secondary waterproof material is the procedure recommended by most art professionals. Keep in mind that you want your works returned with the same care you have taken to send them. Your use of simple, durable wrapping materials that are easy to reassemble will encourage this behavior.

Transporting Uncrated Works of Art

A well-wrapped painting or sculpture can be transported locally, or on longer surface trips, without crating. However, you should supervise the operation completely or hire someone who is familiar with handling artwork. For greatest safety, wrapped paintings should be stacked vertically with cardboard separators when in a van or truck. Stacking paintings in a horizontal position places too much stress on supports and surfaces and is not recommended. Take care to cushion the bottom surface of the vehicle with a blanket, or some form of padding, to absorb vibrations and to facilitate sliding the art in and out. Vertically stacked paintings should be held in place with strong adjustable belts that can be attached to the inside walls of the vehicle.

Well-wrapped and padded three-dimensional objects can also travel by surface without being

crated. Smaller objects should be braced in their storage boxes or in cartons selected to suit the size and weight of the object. Blocks of polyethylene foam, loose-fill packing material, or bubble wrap can be used to fill excess space to prevent movement within the container. The type of divided carton that can be found in liquor or beverage stores is convenient for packing small objects, or component parts of a single sculpture. Large objects can be transported free-standing, covered with blankets, and braced within the vehicle. Position the object so that the center of gravity is low and balanced. Heavy objects, whether free-standing or in boxes, should travel on pallets or skids to permit unloading with a forklift.

Non-fragile two-dimensional works that are well-wrapped and packed in cardboard cases can travel by air without the protection of a crate. Prints and original works of art on paper that are unframed are particularly suited to this method of transportation. Lightweight, sturdy, three-dimensional objects can also survive uncrated travel if they are protectively wrapped and well-cushioned in their boxes. Due to the likelihood of rough handling, it is not recommended that any framed work of art, canvas on stretcher, or fragile object travel by air without the protection of a crate.

You should observe the following guidelines for packing if you decide to transport artworks by air without crating. Works on paper should be wrapped protectively with glassine, housed between rigid boards, and covered with a waterproof wrapping before packing. Three-dimensional objects should also be individually wrapped with glassine or tissue paper and plastic wrapping, and cushioned within their boxes with strips of semi-rigid foam

blocks. As stressed in the discussion above, a waterproof wrapping will create a barrier against liquid spills and ample cushioning will protect your work from bumps and jolts.

Mailing tubes are one of the most common and economical means for transporting unframed works on paper. While rolling any work of art has its pitfalls, tubes can be a safe and efficient mode of transportation. In general, works on paper should be rolled only if the surface is not vulnerable to cracking or distortion. Work should always be rolled with the the image facing out. Avoid rolling work too tightly by selecting a tube with an ample diameter. When mailing more than one work, intersperse the stacked works with acid-free inter-leaving paper and wrap the entire package with glassine before rolling. Bubble wrap can be in-serted in the free space on either end of the tube to buffer the fragile ends of the paper.

Sending uncrated works of art by postal service can save time and money, but factors such as insurance limitations and the possibility of rough handling should give pause for careful consider-ation. Insurance and packing restrictions for send-ing art via private and public postal services are discussed in Chapter 9.

Crating Works of Art

Crating is recommended for all long distance travel or for transporting any particularly fragile or vulner-able object. The primary purpose of a crate is to protect against damage from handling. Crates can also be constructed to provide an environment that is water-repellent, thermally insulated, and shock absorbent. At least three principles govern the

proper placement of an object within a crate: 1) the object is suspended in a cushioned space; 2) the packing materials are arranged so that they maximize thermal insulation; 3) the packing materials are organized in a manner that facilitates easy reassembling and safe return of the object.

A crate should be constructed out of plywood and fastened with either screws or nuts and bolts. The plywood should first be sealed with several coats of polyurethane. Lids of crates should never be fastened with nails as the vibration from hammering can threaten the stability of the enclosed object. Also, the removal of nails often destroys the crate, preventing its reuse. Screws are less stressful to the object and are easier to remove. Large crates, particularly those intended to hold heavy items, should be constructed of thick plywood, be reinforced with pine battens, and be fitted on the bottom with runners (Figure 8.2). This will assure that the crate bottom is not directly in contact with the floor, which makes loading and unloading with a forklift easier. Most importantly, this protects in case of flooding. The size of the crate will be determined by the size of the object plus the dimensions of interior packing materials. Before constructing a crate, check the dimensions of all access ways, such as entrance doors, corridors, and elevators, as well as the size of the vehicle used for transporting the art, to make certain that the crate will pass through. Shipping specifications may also place certain restrictions on the size and weight of your crate.

Weight Distribution
A crate can be constructed to house one work or multiple works of art. The approximate weight of

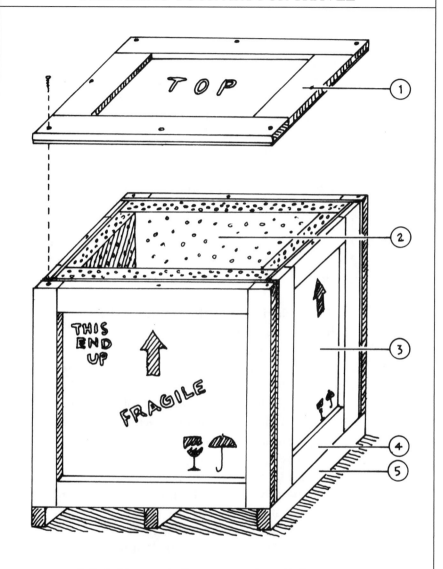

1. Crate lid secured with screws or nuts and bolts
2. Crate lining glued to plywood
3. 1/2" to 3/4" plywood
4. 1"X4" pine battens
5. 2"X4" runners

FIG. 8.2 CRATE DESIGN

objects, packing materials, and crate should be calculated in advance both for ease of handling and to comply with any shipping restrictions. A good rule of thumb limits the weight and size of a crate to that which can be handled by two able-bodied people. Even distribution of weight is another point to consider. It is safest to pack works of a similar size together, but if that is not possible, take particular care that the objects are placed to balance the load. Similarly, you should avoid packing light and heavy objects together unless there is a secure divider between them and the weight in the case is balanced. Fragile objects should always be packed separately.

Packing Principles: Waterproofing, Thermal Insulation, and Cushioning
The crate alone does not protect the artwork. For maximum protection, it should be waterproofed, lined with thermal insulation, and cushioned for maximum protection. Ideally, all interior packing should be attached to the crate walls so that when the crate is repacked its protective features remain intact. Materials recommended for packing include rigid boards, such as corrugated board, fiberboard, and foam-cored board, and pliant materials, such as felt, plastic sheeting, polyethylene foam sheets and blocks, and loose-fill foam pellets (Figure 8.3).

The principle of thermal insulation is to select and arrange materials so that they maintain a stable internal environment, limiting the expansion and contraction associated with environmental fluctuations. If the temperature and humidity fluctuate on the outside, it should be possible to mitigate these extremes by the deliberate juxtaposition of synthetic and natural materials.

1. Plywood
2. Waterproof barrier
3. Polyethylene foam
4. Hygroscopic material (corrugated cardboard)

FIG. 8.3 CROSS SECTION OF A CRATE WALL

All interior walls of the crate, including the lid, should first be covered with a waterproof paper that can be glued to the surface. The plywood walls should already be sealed with coats of polyurethane or oil-based paint. You should wait at least a few days after painting or applying polyurethane before assembling the crate. This allows for proper drying as well as vaporization of toxic fumes before assembling the crate.

Shock absorbent materials such as foam-cored board or polyethylene foam form the second protective layer. Any layer of cushioning should be in direct proportion to the weight and size of the object. One inch foam-cored board may be adequate protection for a lightweight object, but not strong enough for a crate of paintings. Products such as Ethafoam come in a variety of strengths and

densities. Knowing how to select cushioning that will provide enough protection under the duress of shock may require some product research. Dow Chemical, manufacturer of Ethafoam brand products, distributes a guide to protective package design that details the performance of its product at differing impact levels in proportion to the weight of the object. On average, cushioning materials can range from one to five inches in thickness, depending on the fragility and weight of the object. Cushioning materials should also be capable of protecting from multiple impacts, and therefore be resilient enough to recover after the first shock. Cushioning material such as styrofoam may become crushed after initial compression and consequently will lose some of its protective characteristics.

Foam-cored board and polyethylene foam also act as moisture barriers and thermal insulators. Together with a third layer of moisture-absorbent material, expansion and contraction can be kept to a minimum and internal humidity and temperature levels can be stabilized. The moisture-absorbent lining can be fiberboard, corrugated cardboard, or felt, and applied directly to the cushioning material with archival quality glue. Often, a crate will be fitted with additional blocks or strips of polyethylene foam to brace objects or fill in excess space. These can be glued directly to the innermost lining. All protective linings should cover the interior walls of the crate and lid completely.

For the insulation features to be effective, the crate must be placed in the same climate as the work of art for at least a day, and preferably up to a week, prior to packing and travel. Consider what would happen if, for example, your crate was made from plywood that was stored in a warehouse ten

degrees cooler and considerably drier than your studio or storage space. If the object was packed and shipped without allowing time for the crate to adjust to the new levels, it would be subjected to a destabilized environment during the process of acclimatization. The resultant expansion and contraction of the object could cause surface and structural damage, ranging from cracking paint to mold growth. Preconditioning will assure that the interior stabilizing materials, the crate structure, and the object are acclimatized to the same conditions before traveling. For the same reason, a crate should be allowed to adjust to a new climate for at least a day before opening on the receiving end, particularly if the crate has been transported in cold temperatures and is received in a warmer zone, or vice versa.

If the crate is assembled and lined according to all of these principles and with the necessary precautions, it should guard against the three main perils of travel — water, weather fluctuations, and shock.

Packing Two-Dimensional Works of Art

In general, paintings and works on paper should be transported in an upright rather than flat position. This lessens the amount of strain on surfaces, frames, or glazing. The positioning of hinged works on paper is particularly important as the hinge support is dependent on gravitational pull. An upside down placement risks pulling the paper from its backing board.

Flat stacking is not recommended for paintings, but may be suitable for framed works on paper. Well-wrapped works may be stacked horizontally in

protective crates and separated with rigid dividers. This method is safest for framed works on paper that are uniformly sized (Figure 8.4). This system requires that the dimensions of the crate be custom constructed to fit the size of the works. Particular

1. Felt covered corrugated cardboard dividers
2. Work wrapped in glassine
3. Semi-rigid foam spacers on all four sides

FIG. 8.4 HORIZONTAL STACKING FOR FRAMED WORKS ON PAPER

attention should be paid to lining the sides of the crate with a thick shock absorber and selecting dividers made of sturdy material. Strips of polyethylene foam should be cut to form a protective border around each wrapped work.

Tray packing is a more protective version of horizontal stacking for works on paper. Custom-sized, permanently padded trays ensure better weight distribution, increased protection for surfaces and frames, and ready-made protective return packing (Figure 8.5). When choosing this method of packing, the crate should be constructed to measure

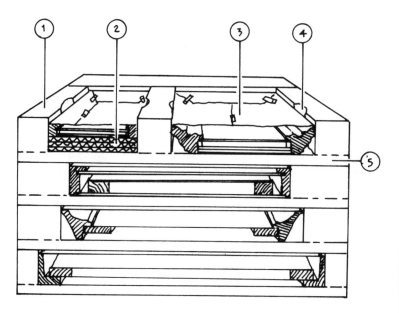

1. Foam blocks or stacks of corrugated board
2. Stacked corrugated cardboard to raise level in tray
3. Works wrapped in glassine
4. Notches for easy removal
5. Rigid divider

FIG. 8.5 TRAY STACKING FOR FRAMED WORKS ON PAPER

at least four inches larger than the length and width of the largest work in the group. Use uniformly sized dividers that are cut to the dimensions of the crate interior to form the bottom of each tray. Cut strips of polyethylene foam to form a snug frame around each work and then glue them down to the divider. The foam strips should extend at least a quarter of an inch above the work to form a protective rim. Small notches can be cut to form finger holes for easy removal of the work. Mark each tray with the description of the work that fits inside. Stack works into the crate in order of size and/or weight.

Upright packing is recommended for the transportation of all paintings. It is safest to transport similar sized works together. If the crate is well constructed with shock absorbent lining, wrapped works may simply be placed side by side and separated with rigid dividers. Eliminate excess room with extra cardboard dividers. The works should fit snugly, but without pressure, into the crate. Extra protection can be gained by padding the exterior side of the outside dividers. A more protective version of vertical packing features plywood slats secured in place with glue and screws (Figure 8.6). The slats can be lined with felt or foam sheeting for additional cushioning. After placing the wrapped works in the slots, any extra space should be filled with corrugated cardboard or bubble wrap to reduce the movement of the work.

Packing Three-Dimensional Objects

Before packing any three-dimensional object, you should examine it and decide whether it must be dismantled either from its base, or into its compo-

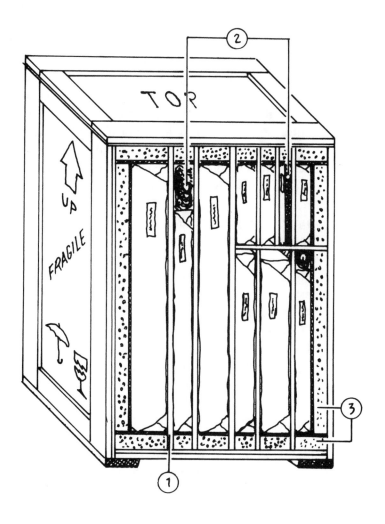

1. Plywood dividers covered with felt
2. Extra space filled with corrugated cardboard
3. Foam blocks for cushioning

FIG. 8.6 VERTICAL PACKING WITH PLYWOOD DIVIDERS

nent parts. Movement from vibration or from shock will undermine the weakest parts of an object, so care must be taken to determine in advance whether an object can withstand sudden jolts without breaking. Any weak areas of the object should be supported with the use of foam braces. A sculpture that is a single unit should be positioned so that the center of gravity is low to the bottom and stable.

Three-dimensional objects are generally float-packed in a single crate. Since three-dimensional objects are often inherently irregular in shape, precautions must be taken to protect all surfaces from coming into contact with the crate walls. A crate constructed for three-dimensional objects should always include ample cushioning. Sculpture should be wrapped first with a soft material such as tissue paper or cloth, and then covered with protective padding.

Current theory runs counter to the traditional use of loose fill packing. It appears this method has more disadvantages than advantages. The use of new materials has replaced the once common practice of floating objects in foam pellets or foam string. Some of the disadvantages to loose-fill packing include: a) the tendency for all but the lightest objects to migrate to the bottom under constant vibration; b) the likelihood that much of the filling will be thrown out when it is unpacked by the receiver, thereby risking inadequate padding when the shipment is returned; and c) the risk of accidently overlooking an object, since its shape and placement are unclear to the person who unpacks it.

Professionals now recommend the use of polyethylene foam as protective padding for three-dimensional objects. In this packing method, the object is encased between two foam blocks and secured with

tape or twine. Figure 8.7 illustrates how the general shape of an object can be carved into foam blocks to form a protective shell. Make sure that the wrapped object fits snugly into its container and that the two halves are joined together with tape or twine. The foam container can be placed directly into the crate. Extra space can be filled in with bubble wrap or foam strips. Creating several cavities in one foam block is a useful way to assemble small component parts of one sculpture. In general, when several smaller items are placed together in a crate, they should be separated, either in foam blocks, or by rigid dividers. Light objects that are well wrapped can be safely floated in loose-fill packing material.

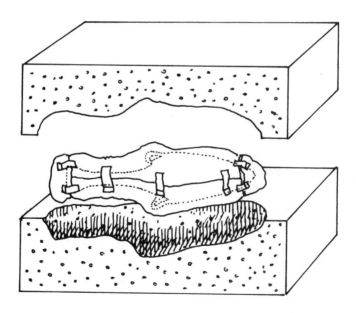

**FIG. 8.7 PACKING THREE-DIMENSIONAL OBJECTS
CROSS-SECTION OF A FOAM BLOCK**

The most protective method for packing objects is the package-within-a-package system. This double packing method involves the suspension of an inner, independently packed, box within the crate (Figure 8.8). Sturdy boxes used for storage purposes can be converted to house the object during transit (see Figure 3.10). The inner box should contain the wrapped object surrounded by protective padding and the exterior crate should be constructed with appropriate waterproofing and thermal insulation. The box can be supported in the crate with foam blocks that are attached to the crate walls, or floated in tightly packed loose-fill, depending on its weight. Although more time-consuming than single-crate packing, the package-within-a-package method offers maximum protection and may be reserved for those objects whose value or condition warrants extra care.

Crate Handling Instructions

Handling instructions must be labeled clearly on the exterior of the crate. Internationally observed symbols are used to communicate proper handling instructions for crates containing works of art. The most commonly used are: the broken stem glass, which indicates a fragile shipment; the umbrella, which signals that the crate should be kept dry; and the arrow, indicating which end is up. These symbols should be stenciled onto each side of the crate and made large enough to be read at a distance. Figure 8.9 can be enlarged and used as stencils for tracing these symbols on the side of your crate. Often, for foolproof handling, the symbols are accompanied by their English language translations, i.e. Fragile or This End Up (see Figure 8.2).

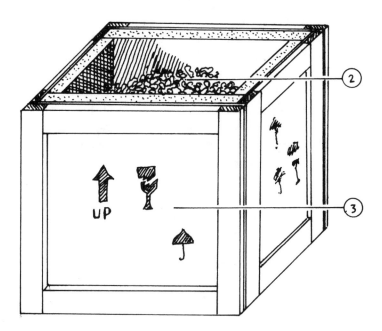

1. Cardboard box with packed object
2. Loose-fill
3. Thermally constructed wooden crate

FIG. 8.8 PACKAGE-WITHIN-PACKAGE

The box should also be clearly marked with its weight, size, destination, and sender. If you are sending more than one crate, number them consecutively and indicate the total number of pieces in the shipment on each crate. For example, 1 of 3, 2 of 3, and 3 of 3 labeled clearly on your crates will help a handler keep the shipment together. It is also helpful if your crates are visually uniform. If you have assembled a motley collection of secondhand crates for your shipment, try to relate them by painting the exteriors the same color, or by labeling them in an identical fashion. This simple measure will keep your work together when your shipment is only one in a container of many other crates.

For reasons of security, the contents of the crate should not be listed on the outside. Details concerning the contents, proper unpacking, and repacking methods, should be written down and attached to the inside of the crate lid so that the recipient sees this information prior to unpacking. Other documentation, such as instructions for assembling and installing the work, condition reports, photographs, and loan forms should also be positioned prominently on the inside of the crate. An envelope holding this information should be protected with plastic wrapping.

FIG. 8.9 KEEP CRATE DRY, FRAGILE, THIS END UP

Chapter 8 Checklist

Wrapping and Packing Materials

❏ Glassine
❏ Tissue paper
❏ Plastic sheeting
❏ Bubble wrap
❏ Polyethylene foam (Ethafoam)
❏ Foam-cored board or fiberboard
❏ Felt or padded paper
❏ Masking tape
❏ Archival glue
❏ Corrugated cardboard
❏ Padded blankets
❏ Cartons or storage boxes
❏ Loose-fill foam pellets
❏ 1/2 to 3/4 inch plywood
❏ Screws, nuts and bolts

Packing Procedures

The physical characteristics of your work, its destination, and the mode of transportation are important considerations for safe travel.

❏ Use simple, durable, and acid-free materials to wrap objects
❏ Pad corners of paintings and frames
❏ Tape glass glazing to protect work during travel
❏ Use rigid portfolios to protect unframed works on paper

Crate Construction

- ❏ A safe crate is waterproofed, thermally insulated, and cushioned
- ❏ Precondition crates to the same environmental levels as the works of art
- ❏ Make sure that weight is evenly distributed in crates
- ❏ The density and thickness of cushioning should be proportionate to the weight and fragility of an object
- ❏ Paintings should be packed in an upright position
- ❏ Loose-fill packing may not adequately protect objects
- ❏ The package-within-a-package method is best for highly vulnerable objects
- ❏ Label the crate clearly on all four sides
- ❏ Documentation should be clearly visible to the recipient

9

Transporting
Your Art Safely

Considerable technology and expertise have been devoted to the study of transportation for works of art. Museums regularly use special trucks which are designed with shock absorbers, insulation, temperature and humidity controls, safety devices, and alarm systems. These vehicles are driven by trained art handlers. Compared to the readily available and relatively low budget shipping and postal services, the more costly means of specialized art transportation may be difficult for the average artist, art dealer, or collector to justify. Deciding when to spend more for protection is dependent on knowing the physical characteristics of your artwork, the capability of the mover, and the risks you are willing to take. Weight, size, number of boxes, budget, and distance are all factors which will help determine the choice of transportation.

The transportation services most commonly used by the individual to transport works of art are road

or air transit. It is less likely that the individual artist or collector would use boat or train as a mode of art transportation. There are times, however, when such shipments may be desirable as an economical alternative, especially for large, heavy sculptures. Keep in mind that when art is shipped as cargo, it is treated like any other cargo and may be handled roughly. Artworks traveling by these means must be extremely well packed, able to withstand rough treatment, and often will be subject to environmentally hazardous conditions. Overseas shipping requires a number of customs documents to be processed, and will probably require the use of a customs broker to aid in sorting through the often perplexing import and export regulations. Be prepared for transits which may last for several weeks or more, once the standing times on docks before and after shipment are factored in.

Transportation by Road

Works of art can be transported in your own or rented vehicle, with regular household movers, or with the professional services of a fine art mover. First check your insurance policy to see whether it stipulates that a fine art mover must be used. Regardless of the carrier, certain safety guidelines should always apply when art is being moved.

A work of art should always be moved by two people. When hand delivering a work of art, one person should have the exclusive responsibility of carrying the art package while the other person attends to opening doors, operating elevators, and in general guarding against potential accidents. Works of art should never be left unattended, even during restroom or refreshment stops. One person

should always stay with the vehicle. Keep in mind that, apart from the risk of personal loss, artworks stolen from unattended vehicles are usually not covered under fine arts insurance policies. If you have hired someone else to move your art, try to be on hand during loading to make sure that it is placed securely in the vehicle. For long distance travel, vehicles should be able to be locked and parked overnight in an enclosed, guarded parking lot or art-holding area. For very valuable works of art, you may want to be assured that someone is guarding the vehicle twenty-four hours a day.

It is important to limit your art's exposure to fluctuations in temperature and humidity. During cold or damp weather, try to minimize the number of times the doors of the vehicle are opened and closed. Temperatures in overnight storage areas should be a steady seventy degrees. Unloading and loading areas — points when the object is most exposed to the elements — should be sheltered from rain, wind, and water drainage.

Commercial movers offer door-to-door services that can be on an exclusive or shared-space reservation basis. House movers who specialize in moving valuable or fragile objects should be sensitive to handling artworks and may even offer specialized packing services that can follow your specifications. A preliminary phone call to ask questions and give the details of your specific needs should help in determining whom to hire. Most commercial movers, however, are not equipped to offer the special purpose vehicles that inhibit shock and vibrations and provide for environmental controls. For this type of equipment, you should contact a mover specializing in fine art.

Fine art movers can provide climate-controlled

vans with air-ride suspension systems, and personnel skilled in handling art objects. This type of service will undoubtedly be more costly, but it will help ensure the safety of your art. As it is more expensive to hire a truck exclusively, it may work to your advantage if you can coordinate your shipment with a pre-scheduled route. Keep in mind that joining another shipment may take longer and mean that your work will be temporarily stored prior to reaching its destination. Larger companies often make regular runs to major cities throughout the country. A call to your local museum, an established art gallery, or auction house will provide you with recommendations for professional art movers. Advertisements for art movers can also be found in the backs of most national monthly art journals. Consider the answers to questions such as whether their storage facilities are secure and climate-controlled, and how direct or circuitous the route for your shipment will be (the more stops, the more risks), before making your decision.

Transportation by Air

Air transport is the most common, efficient, and safe means of moving art over long distances, domestically or internationally. Your choices include parcel services, such as those offered by the United States Postal Service, United Parcel Service (UPS), DHL, Federal Express, and other private companies, or commercial air freight carriers.

Parcel Services

Many artists and art institutions have used the United States Postal Service, UPS, DHL, or Federal Express without any cause for complaint. Economy,

convenience, and fast service are to their credit. However, restrictions on size, weight, and insurance impose limitations that may not be suited to your art. In general, these mail services are best suited for small, non-fragile artwork of relatively low value.

Insurance in particular is a tricky issue. The United States Postal Service has a fairly low limit on insurance. First class or priority rates, rather than surface rates, are advisable for best handling and maximum insurance coverage. Federal Express has a $500 liability limit and DHL will accept insurance values up to $25,000 for an additional cost. In both these cases values must be substantiated by documentation, such as previous sales for similar work, to support your claim in the event of loss.

Sending works of art to international destinations through the United States Postal Service can be problematic. Differences in jurisdictions can make the processing of a claim very complicated and time-consuming. For international destinations, it is better to use a private company, such as Federal Express or DHL. As these companies specialize in international air service, they have more efficient systems in place for processing claims.

Air Freight Carriers
You can use air freight carriers to transport crates or boxes containing larger artworks. Keep in mind that most air freight, like surface freight, is treated like other cargo and will be subject to greater hazards. Some air freight carriers offer special fine art handling services, which may include climate-controlled and pressurized cargo areas (to deal with changes in altitude), for an additional cost.

Transporting art by air can be facilitated by using a freight forwarder. A freight forwarder will act as

an agent for your shipment and should be knowl-
edgeable about the policies, requirements, and
schedules of all kinds of carriers. He or she will
arrange for transfers door-to-door, contract with
individual commercial carriers, take care of all
invoices, receipts, bills of landing, air waybills, and
all import and export licensing if the work is travel-
ing internationally. Because a freight forwarder has
access to loading areas, he or she can also make
sure that your crates are placed securely in their
container. To avoid any hidden costs, make sure
that any estimate you obtain from a freight for-
warder reflects all of the above.

Loan Forms

It is the practice of most institutions to issue a loan
form when borrowing a work of art. A loan form
generally stipulates the conditions under which the
work will be insured, travelling and handling
procedures, the length of the loan, and any special
conditions for its display. It is the responsibility of
the borrower to respect and observe the conditions
outlined in the loan form. Lenders should be
careful to note the terms under which the artwork is
insured. Wall-to-wall coverage, meaning that the
work will be insured from the moment it is picked
up to the moment it is returned, is essential.

As a matter of course, but more particularly to
avoid hidden expenses or responsibilities, be certain
to read the fine print on loan forms before signing.
Although most museums will issue loan forms as a
standard procedure when requesting an object,
galleries and non-art institutions may be reluctant to
observe stringent standards and their loan forms or
consignment agreements may be modified accord-

ingly. At a minimum, the general rules of safety outlined in this book should act as a guideline for drafting a consignment agreement with galleries. A model loan form, with a checklist for evaluating loan forms you may be given, appears in *Business and Legal Forms for Fine Artists* by Tad Crawford (Allworth Press).

Chapter 9 Checklist

Transportation Guidelines

Safe long distance or local travel requires careful planning and attention to certain guidelines.

- ❏ At least two people should accompany the moving of art
- ❏ Works of art should never be left unattended
- ❏ Avoid storage, loading, and off-loading areas that are not sheltered from rain, wind, and water drainage
- ❏ Fine art movers offer many special features for safe transportation of art
- ❏ Parcel services are recommended only for small, non-fragile artworks of relatively low value
- ❏ Freight forwarding agents are used to facilitate air transportation of works of art

10

Insuring Your Art

The preceding chapters have outlined principles for ensuring the safekeeping of your art. It has been stressed that someone who attends to the studio environment, creates proper storage areas, observes safe handling practices, organizes inventory, packs protectively, and transports art carefully, will reduce the risks to which art is continually exposed. In this chapter, the words insurance and risk take on new meaning. While preventive care will certainly ensure better protection for your art, the evidence of such care may be a prerequisite for obtaining fine arts insurance. Establishing a safe environment and instituting proper procedures for handling art offer proof to a claims adjuster that you have exercised all necessary precautions if, in spite of everything, there is an accident or damage to your art.

Insurance exists as a safety net, at least in terms of dollar remuneration, when unavoidable events occur. In this regard, artists are advised to protect

against all risks, including illness and accidents caused to others on their premises, by buying personal health and liability insurance. The consequences of personal liability suits and major illnesses can be debilitating, emotionally, physically, and financially. When you are weighing options for the most affordable plan, you should ask yourself whether you can afford not to have adequate personal and business protection. However much this point needs to be stressed, these issues are beyond the scope of this book. This chapter will focus on fine arts insurance coverage for works of art and studio materials.

The Business of Insurance — Losses and Gains

The issues of risk reduction and risk prevention are of paramount importance to the insurance claims adjuster. Fine arts insurers want to know that you are taking the necessary precautions to protect your art before they issue a comprehensive insurance policy. Whether or not you take such precautions may affect your claims settlement, since insurers often try to pay less than the value for which they have insured art.

Stricter guidelines in fine arts policies have evolved in keeping with the pace of change in the contemporary art world. New uses of materials and media, increased travel of museum exhibitions, the proliferation of galleries, the expanding market for contemporary art, and the astronomical rise in sales prices for art at auction, all have exerted pressure on the insurance industry. In one form or another, these forces have caused insurance companies to be more attentive to the needs of artists, private collectors, and museums on the one hand, and more

restrictive in their coverage on the other. This has also prompted more exclusions and disclaimers to be written into policies as insurance companies endeavor to protect themselves against unreasonable claims and preventable risks.

While the growth in the industry has been beneficial to artists in view of the many new group plans for all risk fine arts insurance, it has also taken its toll. As the stakes have mounted, so too have the requirements of insurers. In addition to increased premiums, insurance companies now expect artists and private collectors to be more aggressive in observing preventive care. Damage resulting from inherent vice, material contamination, and environmental exposure are significant exclusions in many fine arts policies. Professional packing and shipping standards are stipulated as a requirement in many policies. Essentially, insurance companies are saying that ignorance is no excuse for subjecting works of art to risks and they are not willing to pay for the consequences.

Insurance Options

As the business of art has expanded, options for insurance policies have also increased. At one time it was not possible for artists to obtain all risk insurance to cover their work on the studio premises, while in transit, and on temporary site location. This prejudice was promoted by the image of the artist as an unconcerned person, an outsider who by his or her nature did not pay attention to practical considerations. It was further encouraged by the myth of the starving artist, living on little and creating work without commercial value. This was not the profile of an individual an insurance com-

pany would want to risk insuring. Times have changed, and it is now possible for artists of modest means to obtain all risk insurance coverage for a minimum annual premium. Artists with active careers can combine homeowners, business, and studio insurance with the help of brokers specializing in the concerns of art and artists.

The profiles of collectors have also changed over the years. Not so long ago, inventory valued at $1 million was considered an extraordinary amount for a private collection. Now, with individual paintings valued in the millions, it is not uncommon for art collections to be appraised on the multi-million dollar level. The unpleasant reality of astronomical premiums for insurance coverage has placed a financial burden on collectors. As a result, collectors are less willing to lend work, ultimately affecting museum exhibitions, and consequently, the public. The sometimes prohibitive cost of restoration, the agony of replacement, greater risk awareness, and the intensive labor involved in transporting valuable art, have made everyone more conservative.

Of course, not all artists are in the "emerging" category, nor are all private collections valued at $1 million dollars or more. But these extremes are not unrelated and raise pertinent points when considering which fine arts policy to buy. How best to determine the value of your work, how much coverage to buy and at what cost, and the limits of coverage, are relevant questions for anyone in the market for fine arts insurance.

What is a Fine Arts Policy?

.Fine arts policies insure art and the materials used in making art, against fire, flood, theft, and acci-

dents, on the premises, in transit, and at temporary locations. A fine arts policy is recommended for anyone who owns or cares for art of value. Fine arts policies can be customized to address the special needs and risks associated with art inventory in studios, private homes, galleries, and museums. Minimum and maximum values coverable on a fine arts plan vary from company to company. For example, an artist who estimates inventory and supplies to be valued at $15,000 may not make the minimum on certain insurance policies. On the other hand, a very valuable collection may be priced out of some plans, requiring specialized coverage at a higher cost.

An artist who lives and works in the same quarters should pay particular attention to the need to combine several plans for comprehensive coverage of home and business items, materials, supplies, and inventory. Homeowners, business, and fine arts insurance policies each specify the limitations of their coverage. For example, tools and materials are covered under a fine arts insurance policy, but studio furniture and an art library are not. To be adequately protected, you should consult with an insurance agent specializing in fine arts coverage to devise a plan best suited to your needs. Ask colleagues or the registrar of a local cultural institution to recommend a qualified broker.

Group Insurance Plans

Many artists are not able to purchase a fine arts policy through a local broker. This may be because their inventory is of too little value, or because their local broker is not equipped to issue a fine arts policy. To address this need, several national organizations offer very reasonable all risk fine arts

insurance plans to their members. One of the incentives to joining such organizations is to be able to benefit from their reasonably priced and comprehensive plans.

The Artists Equity Association and The International Sculpture Center are two national membership organizations based in Washington, D.C. that offer all risk fine arts insurance programs to artists and sculptors, respectively. Both programs insure works of art, tools, and materials against direct physical loss or damage in the studio, while in transit domestically, and when on temporary location. These plans cover only works of art made by the insured, and do not cover damage to works of art by other artists which are in the studio. Certain exclusions apply, including damage resulting from inherent vice, from weather exposure, damage occurring in transit by unregistered mail, and theft from any unattended vehicle. These exclusions should underscore the point that losses or damages related to negligence are under your control.

Annual insurance premiums for these plans average around one percent of the total covered amount for painters and around one and a half percent for sculptors. Minimum coverage begins at $15,000, at a rate of $250 and $350 for painters and sculptors respectively per year. The maximum coverage is $100,000. There is a limit of $15,000 reimbursable per item. Transportation shipments may not exceed $20,000 for sculpture and $25,000 for paintings. Artworks damaged or stolen from your premises are insured for 100 percent of their net value. Paintings damaged or stolen in transit or off the premises are covered for 50 percent of the net value. Sculpture is covered for 50 percent while off the premises, but only for 25 percent while in

transit. There is a $250 deductible for each claim (which may include damage to or loss of more than one item).

Valuation of Art

In the eyes of the insurance company, the insured value of a work of art is what you and they agree on. Depending on whether you are an artist, a dealer, a private collector or a museum, there are different methods for arriving at the insurance value of a work of art. Value may be based on the amount an artist receives for the sale of the work, the sales or purchase price, fair market value as established by auction price, or, as in such cases as when a blanket value is assigned to a group of works, a legitimate amount agreed upon between the client and the broker.

The insurance value of a work of art in an artist's studio is usually established according to net value, or the percentage that the artist would receive if the work were sold through a gallery. The lack of an established market or gallery affiliation has made it difficult for some artists to obtain insurance. However, just because you are not represented by a gallery does not mean you cannot buy insurance. Any evidence of prior sales, whether through a previous gallery association, or a private transaction, can be used to support a working value for insurance purposes. The plans offered through the Artists Equity Association and The International Sculpture Center stipulate that all completed works, or works in progress that are sold or are under contract for sale, shall be reimbursable at net value. Work in progress not sold or under contract for sale is valued at the cost of the materials and labor, not exceeding

$1,000 for each painting or $5,000 for each sculpture. The insurance value of a work owned by a private collector is usually determined by the fair market value of the object. A valuation clause is commonly used to itemize individual works and to outline what the company will pay in the event of a covered loss. Valuation clauses should be updated at regular intervals, particularly if there is evidence that the collection is rapidly increasing in value. New valuations of works of art must be substantiated by comparison with recent sales records of similar items at auction or in galleries. Updated values can be obtained from a local auction house, any legitimate appraisal service (such as that offered by the Art Dealers Association of America), or through a reputable art dealer.

Transfer of Liability

There are times when the transfer of liability for your artwork is reasonable and advisable. Such cases may occur when you use the services of a fine arts shipper, when you consign work to a gallery, or when you are lending work for an exhibition. For an artist, the most common transfer of liability occurs when work is on consignment to a gallery. It is reasonable to expect that an art dealer will provide complete insurance for any works on their premises, or elsewhere under their auspices. The terms of this agreement should be stated in writing and signed by both parties. Artists should try to review consignment agreements in advance to familiarize themselves with the terms of the coverage. All consignment transactions should be kept in duplicate as documentation in the event of loss or damage. If you do not have an exclusive relation-

ship with a dealer, or tend to be sending a lot of work to various places, it may be easier and more reassuring not to transfer liability. This will save you the time of reviewing someone else's insurance policy, or having to make a claim to another company. However, it does mean that you will have to absorb the deductible in the event of a loss or damage.

Private collectors and artists are often given the option to transfer liability when they are using the services of a fine arts shipper. Many fine arts transporters provide all risk coverage for their clients. When selecting this option, it is important to ask the transporter on what basis a claim will be reimbursed, and whether all risks are covered. Be certain to ask if there are any exclusions in the coverage and what, if any is the deductible. If there is any doubt about the way the contract is phrased, do not accept the coverage; rely on your own insurance. When it can be trusted, transfer of liability is advantageous because it places the holder responsible for complete restitution of any loss or damage to your work and frees you from paying a deductible on your loss.

Tranferring liability does not mean that you forfeit your own insurance coverage. Your all risk fine arts insurance should protect you in instances where a claim through another company is contested, refused, or only partially reimbursed. You should ask to review the details in your policy which specify the terms of your coverage in cases of default.

When a museum asks to borrow a work for exhibition, it usually issues a loan agreement form that transfers liability to the borrowing institution and details the terms of the coverage. Museums

usually offer wall-to-wall insurance coverage and will make arrangements for picking the work up at the lender's home or wherever the work is currently located. In addition, they will take responsibility for any special packing and handling requirements. If the work is very valuable, a lender may stipulate that it can travel only if accompanied by trained personnel. Occasionally, lenders will prefer to maintain their own insurance coverage, but may stipulate on the loan form that in the event of damage the deductible will be covered by the borrower.

Inventory Records

As discussed in Chapter 6, the importance of maintaining accurate records cannot be overstated, but this is particularly true when it comes to insurance. The necessity for good inventory records becomes clear if and when a loss is claimed. A claims adjustor may ask you to provide such documentation as a copy of your inventory list, consignment agreements, or sales records to help establish values in accordance with the terms of your policy. Having these readily available will save time and prevent additional stress in an already vexing situation. Be certain to update the value of work in your inventory regularly. As a precautionary measure, all inventory records should be kept in duplicate form off the premises. In the event of catastrophic damage, the complete loss of records and the prospect of reconstructing them would be an even greater setback and would certainly delay your settlement with the insurance company.

Chapter 10 Checklist

Insuring Your Art

Insurance companies expect you to be aggressive in observing preventive care. Acts of negligence are usually not coverable.

❏ Use acid-free materials
❏ Store, handle, and pack art properly
❏ Observe safety precautions when transporting art
❏ Avoid moving fragile and vulnerable objects
❏ Fine arts policies offer specialized coverage for artists and collectors
❏ Group plans provide artists with all risk fine arts insurance at reasonable premiums
❏ Familiarize yourself with all exclusions and conditions in your policy
❏ Be cautious when relying on others' insurance, and read all the fine print
❏ Inventory records should be clearly organized and reflect current information accurately
❏ Stipulate insurance values that can be substantiated by previous sales and receipts
❏ Update valuation clauses regularly

11

Security
for Your Art

Catastrophic loss or damage from fire, flood, or theft conjures up a nightmarish scenario for an artist or collector. Reliable security systems are essential for avoiding such traumatic situations and, in most cases, are required by insurance companies. Devices range from the modest to the expensive and from the simple to the most sophisticated. To comply with insurance company standards, make certain that any security device you purchase has Underwriters Laboratories approval. As is true for many service businesses, a reputable company will provide you with an estimate upon request. It is recommended that you obtain several bids for your job before making a decision.

Apart from the reliability of the product, the most important considerations are competent installation, utilization, and suitability. You should make certain that any device you purchase is correctly installed, that you know how to use it, and that it is suited to the physical requirements of your space. Any insurance company will refer you to a specialist

who can customize a security system for your specific needs. Investment in a good quality and comprehensive system will pay off in the long run.

Fire and Flood Prevention

You can take simple precautions to protect against water damage. Water damage can be thwarted by storing art away from any water main pipes and by elevating it from contact with the floor. Maintaining a careful check on all plumbing fixtures is especially recommended. Well-insulated ceilings and attention to small leaks before they worsen are also essential precautionary steps. For more sophisticated detection, flood sensors can be installed in basements, near pipes, or in any areas where moisture may accumulate. These devices can be wired to relay the location of accumulated water to a central panel.

Fire is best prevented by installing a reliable heat and smoke detection system throughout your premises. The ionization smoke detector is the best system for detecting fire in its beginning stages. Highly sensitive to smoke, the alarm will be activated when sufficient particles reach its chamber. For greatest safety, the alarm should be wired to a central system that can signal the fire department. Avoid installing these devices in any area near excessive exhaust fumes, such as the kitchen, fireplace, or outside vents.

Water sprinkler systems are a two-edged sword. While they are the most valuable fire-fighting systems, they can also cause serious damage to art. A smoke detector will ideally be a sufficient call to action at the onset of a fire, but once a fire has reached the stage of flame, the inevitable damage

caused by water may be the lesser of two evils. Sprinkler systems are designed to sense the source of a fire and will release water only in areas that exceed a certain degree of heat. Sprinkler systems can also be automatically connected to a central alarm system that alerts a responsive party to send firefighters. In the rare event that a sprinkler system is triggered falsely, you should be prepared by knowing exactly where the shut-off valve is located and be able to reach it with a minimum of time and effort. The loss or damage of inventory due to the inability to turn off a sprinkler system is doubly disastrous.

Hand-held fire extinguishers are important to have around for fighting small, localized flames. However, once a fire has reached the level of heat required to set off a sprinkler system, chances are that it is beyond your control. You should contact the fire department instead of taking the risk of combating a potentially deadly threat. Fire extinguishers can operate with either gas, foam, or liquid solutions. Extinguishers containing pure carbon dioxide foam are recommended as the least harmful to works of art. Sodium bicarbonate powder, which can be purchased in grocery stores as commercial baking soda, releases carbon dioxide and can be used to smother small flames. Powder can damage the surface of artworks, so this step is recommended with reservation. Dry sand may also be effective in smothering localized flames.

Theft

Burglar alarm systems are great for detecting unauthorized entry on the premises, but they only notify you once the act of entry has occurred. Fine Arts

Risk Management, a New York based insurance company specializing in fine art, stresses that the key is to make it as difficult as possible to gain entry. They recommend physical security above all as a deterrent to theft. The value of your art or possessions may not be the primary concern of a thief. Easy access will be. Do not be lulled into thinking that your possessions are not worth stealing. Given the choice, most burglars will target the quickest and easiest mark.

Securing all entryways is the best way to deter a thief. Doors should be doubled locked with dead bolts and fire escapes secured with gates. Non-functioning windows should be permanently sealed, and street level windows should have gates. Fine Arts Risk Management suggests that window gates be installed on the interior rather than the exterior of the window. This forces a thief to smash the window first, setting off the alarm before reaching the gate.

Of course, burglar alarm systems can also effectively deter thefts. Sometimes even the visible evidence of a good system will thwart a thief. Alarms that make a loud noise are recommended as the most effective. Motion detectors are relatively inexpensive and are very effective. Operated by an infrared sensor, these devices set off a penetrating alarm at the slightest movement indoors. Perimeter protection on doors and windows is also effective, but expansion and contraction due to weather fluctuations can trigger false alarms. Burglar alarms should be wired to simultaneously send a signal to a central monitor and bring security guards or police to the scene of the crime. You should consult with a security specialist to select an alarm system that best suits your needs.

Off-Site Security

Despite your best efforts to secure your art in your home or studio, theft, fire, or flood may also occur when works are off the premises. When your work is out on consignment to a gallery or on loan for an exhibition, you should inquire about on-site security systems. In addition to secure entry ways and alarm systems, galleries should have cameras installed in areas where art cannot be monitored by the staff. Exhibition sites should always be monitored by a guard during public viewing hours, have only one access way, and be locked and secured during closing hours. Other security considerations, depending on the fragility or value of your art, include the presence of climate-control systems, the use of barriers, locked cases, or wall mounts to prevent vandalism, and restricting the handling of work to professionally trained staff.

Chapter 11 Checklist

Security Measures

Theft, flood, and fire can be prevented by investing in reliable security systems.

❏ Purchase reliable, simple, and suitable devices and have them competently installed
❏ Security devices should be certified by Underwriters Laboratories
❏ Fire may be prevented or controlled by smoke detectors, fire extinguishers, and sprinkler systems
❏ Select fire extinguishers with carbon dioxide foam
❏ Securing all entryways is the best deterrent to theft
❏ Investigate off-site security when your work is on loan or on consignment
❏ Always check with your insurance policy for security stipulations

12

Using Computers to Help Care for Your Art

by Maria Reidelbach

The first issue to resolve, when considering using a computer to help care for your art, is whether you need a computer at all. There is no doubt that computers have become a ubiquitous object in the late twentieth century, but it is worth asking whether a computer will actually help manage your art, and how.

What to Expect from a Computer System

Over the last five years, computers have become cheaper and more easy to use, but the investment of money and time that a new system requires are still major considerations. The most basic computer system (including printer and software) will cost at least $1,500. Although a system can be set up in half a day and simple letters can be produced immediately, it will take several weeks of focused effort to become familiar with the operation of the computer, its peripheral equipment, and its software. Lessons are helpful for neophytes. Advances in technology will make a computer obsolete long before it actually wears out. Expect a system to

remain useful, with interim upgrades of software and parts, for about five years.

A good computer system can help you document your inventory by storing basic information as well as information about condition, conservation, location, exhibition history, bibliography, and even an image of the work. It can organize lists of names and addresses, help write letters, including form letters and multiple mailings, and keep accounts. The computer system will store and index all the preceding information and print it out when needed, in various formats that you can choose.

Hardware

The hardware making up a computer system will comprise the following:

Computer or CPU (Central Processing Unit). The computer itself can be based on any of the major operating systems, although the PC and Macintosh platforms are the most popular. Because computer technology is relentlessly advancing, the microprocessor, which is the heart of the computer, should be the fastest you can afford. The computer should have at least 8 megabytes of RAM memory, which allows more, or larger, programs and files to be used at once. The hard drive should have a capacity of at least 350 megabytes; if the number of artworks is large (more than several thousand) or, if hundreds of images will be scanned and stored, the hard drive should be from 500 megabytes to 1 gigabyte. The CPU will also include a floppy disk drive. A CD-ROM drive, while not essential, is helpful to install ever-larger programs that may be installed from up to twenty floppy disks. A tape drive or removable hard drive may be added to make

backup copies of files. It is important that the computer have several empty slots and bays so that it can be upgraded over the years to keep pace with current standards.

Monitor (screen). An SVGA color monitor of at least 14 inches diagonal will suffice, although a larger monitor will allow more information to be seen on the screen at one time.

Keyboard and mouse. Make sure that the keyboard has a comfortable feel. The new ergonomically designed keyboards, mice, and mouse alternatives like track balls and track pads are worth a trial.

Printer. Many excellent and affordable printers are available. Deskjet printers offer good, sharp black and color printing for $200 to $600. Laser printers, at $400 and up, offer extra-sharp monochrome printing. If it is important to you, make sure the printer has the capacity to print envelopes (some portable models and some higher-end laser models do not).

Surge protector. A surge protector guards the computer, printer and peripheral equipment against electrical surges and spikes, which can damage or destroy delicate electronic equipment.

Fax/modem. A fax/modem enables your computer to send and receive faxes and to connect to online services, e-mail and bulletin boards, the Internet, and the World Wide Web. Unless you have a scanner, you will only be able to fax documents that exist in your computer. To receive faxes, your computer must be connected to the phone line and turned on. The fax/modem should be at least 14,400 and preferably 28,800 baud.

Scanner. A scanner is used to copy images into digital form. Scanners range from small, hand-held models that scan only in black and white, to desktop

models that scan paper images or transparencies in millions of colors.

Digital camera. The most recent addition to a computer cataloguing system, digital cameras promise to become practical and affordable in the near future. The digital camera stores images on an electronic chip rather than on film, and you copy them onto the computer's hard disk via a cable connection. Although images may not be of repro-duction quality, they can be a useful and eco-nomical substitute for documentary snapshots, since the cost of film is eliminated, and the pro-cess of scanning the image into to computer is no longer necessary.

Additional computers. It is easier than ever to set up a network between computers, allowing them to share files and programs.

Software

The software, or programming, is the other major component of a computer system. It can include:

Operating system. This is the essential, basic language of the computer: Windows and Mac OS are the two main platforms, OS/2 and UNIX are two others. Unless you are a dedicated amateur or have other compelling reasons, use either Windows or Mac.

Word processor. Many good word processors are available, some are part of a suite of integrated programs, others stand alone.

Database manager. There are basically two kinds of database manager applications: flat and rela-tional. A flat program keeps track of data about one main subject at a time; a relational program can link information from separate main subjects in a dy-namic way.

Accounting program. Can be used for everything from balancing a checkbook to doing payrolls.

Backup utility. An essential program used to make a duplicate copy of files onto floppy disks or magnetic tape.

Fax/modem software. These programs are used to send and receive faxes and to connect to online services and the Internet. Usually, the more mainstream products work the best and are easiest to use.

Scanning and image-editing software. Used to operate the scanner and to size, crop, and retouch photographic images. Old, obscure, or oblique photos can be easily straightened, brightened, and sharpened.

Security or encryption software. Important if data or files are sensitive or confidential, security options may be included with the word processor, database manager, or operating system in the form of passwords used to open files, or may be a separate program that locks the entire computer. When deciding on the need for security one should consider the possibility of burglary of a desktop computer and theft or loss of a laptop computer.

Database Managers

The database manager is the computer application that will store and organize documentation of your artwork. Many database managers are available, from simple, off-the-shelf general applications to complex, custom-designed cataloguing programs. Documenting artwork is specialized and varied enough that it is hard to find widely released software that is dedicated to this task.

There are three main options available to the artist, collector, or dealer. The first is to find a

specially made cataloguing database manager. Small companies usually produce this software, and it will *not* be found at the local computer store or in a mail order catalogue. The best way to find the sources for this software is to look for advertisements in art magazines, or to look for company representatives at major art fairs, or, best of all, ask others for referrals. Such a program would be specifically designed for artwork, but might not be very flexible. For instance, it may not allow you to add more categories of information, nor customize printout formats. It would be available for a flat fee, usually from five hundred to several thousand dollars.

The second option is to create your own database manager—not an option for the faint of heart, but an easier task that it may sound. Most major database manager applications, such as Microsoft Access, FilemakerPro, or Paradox, and including those available in integrated programs such as Works, now include automated templates that assist the user in creating custom programs. A database manager to catalogue artwork is similar to business inventory or household inventory templates provided, which would form the basis of the program. This is the least expensive option, costing as little as fifty dollars—it is practicable if your needs are simple and you are comfortable using computer software.

The third option is to have a computer program custom-designed by a software designer who specializes in programs that document artwork. Such a program could integrate all your information management needs, such as cataloguing inventory, managing a contact or mailing list, and keeping accounts or invoicing. This is the most expensive

option; but the resulting software will do exactly what is needed, and the package of services provided could include helpful extras, such as individual training.

Another aspect to consider is ongoing support for the chosen product. Computers are quite complicated, and, chances are, you will run into problems on a regular, if not frequent, basis. It is important to be sure that answers and help will be available when your program is not working for you. Large software publishers always have technical help telephone lines as well as online forums on the Internet—do not hesitate to use them. (Calling early in the day helps avoid a long wait on hold.) The support available from small companies, individual consultants, and designers will vary, ranging from an offering of limited support to charging for support on an hourly basis. Find out in advance, because you will eventually need personalized assistance with whatever product you choose. Additionally, when working with a designer, it is important to have a detailed contract, specifying the scope of the program, scheduling, and any extras.

How to Evaluate or Design a Database Manager

An understanding of how a database manager works is essential when evaluating or designing a database. The idea of a database manager is to separate, identify, and link each datum, or bit of information. Then the data can be arranged, sorted, and searched at will.

The most basic organizing unit of a database manager is the table, which stores all information about a particular subject, such as artwork or names. A table is further divided into fields, each of

which contain a category of information, such as title, date, or media. Each set of fields pertaining to a particular object or person is called a record. If we use a card catalogue as a metaphor, the table would be the file drawer, the records are the individual cards, and the fields are the information on each card.

Unlike a card catalogue, however, where information is printed on paper cards that are stacked in a fixed order in the drawer, each bit of information in a database is linked dynamically. Records can be sorted based on any field almost instantly, such as chronologically, alphabetically by title, or by current location. The database can be searched for records that fulfill any specified criteria, such as works made with charcoal or works over twenty-four inches tall. Data can also be printed in many forms, so that once it is typed in, labels, lists, and other reports that display specific information can be generated automatically.

In more complex systems, the database will be *relational*, which means that a number of tables, such as artwork, names, exhibitions, and publications, can be linked. In a relational database each bit of information is entered into the system once, then linked with all the other information to which it pertains. For a cataloguing system, this would mean, for example, that information about an artwork would be entered into records in one table, and information about exhibitions would be entered into records in another table. Specific artworks and the exhibitions in which they were shown would then be linked. This eliminates the need to type information repetitively when, for example, many artworks are included in the same exhibition. When viewing information about a work of art on the screen, information about exhibition history could be displayed. Conversely, when viewing an exhibition

record, a checklist of artworks could be displayed. Another advantage is apparent when correcting or adding information to records—the change automatically appears in all linked locations.

The structure of the tables of the database should contain a separate field for each category of data that you might want to search in, sort by, or rearrange separately. For an artwork table a field list might include:

- ❏ ID number
 (a unique number assigned to each record)
- ❏ Catalogue number *(you assign)*
- ❏ Artist
- ❏ Title
- ❏ Year
- ❏ Media
- ❏ Height
- ❏ Width
- ❏ Depth
- ❏ Current location
- ❏ Picture
- ❏ Inscriptions
- ❏ Multiple? *(yes/no)*
- ❏ Edition information
- ❏ Archive photo? *(yes/no)*
- ❏ Reproduction quality photo? *(yes/no)*
- ❏ Photo details
- ❏ Provenance
- ❏ Conservation
- ❏ Comments
- ❏ Price
- ❏ Insurance value
- ❏ Appraised value
- ❏ Appraiser
- ❏ Appraisal date

Additional elements of a database manager have to do with entering (typing in) and outputting (usually printing) data.

Forms or *Layouts* are screen designs to make entering, editing, and viewing data as easy and foolproof as possible (Figures 12.1, 12.2). A good form will have an easily readable type. The fields will be in the most logical order, perhaps emulating forms already used in the studio or office. Fields usually should be large enough to display all the data in the field (although even if data is not visible, it is still stored in the database). A form can incorporate a number of devices to make it easier to enter data, such as a drop-down or pop-up list for fields with a limited variety of data, so that the phrase can be selected from a list rather than typed. This feature can be particularly handy with a field like media, where a set of materials can be quite lengthy, but used in a number of works. A form can also include automatic error-checking—insuring that specific fields are completed or that data conforms to defined rules, for instance, validating that the date falls within a specified time period.

Queries are stored sets of criteria that ask the database specific questions. For example, a query could be used to find all of the artworks that include pencil as a medium. Since it is the question that is stored, and not the answer (the set of records found), each time a query is used, or *run,* the record set would change if the underlying data have been changed.

Reports are layouts designed especially for printing. Reports can take any of a wide variety of forms. One report could print out each record on an index card, to create a "hard copy" of the database for reference or backup (Figure 12.3). Another could

FIG. 12.1 AN ONSCREEN ENTRY FORM FOR ARTWORK

FIG. 12.2 AN ONSCREEN ENTRY FORM FOR NAMES

33 80.
Doe, Jane
Tea and Sympathy
1970
Oil on linen

33 X 34"
Inscriptions:
Signed, lower left.
Alt. Titles:
Can We Talk?
Condition:
Excellent.
Notes:
This work should be hung 36 inches from the floor.
Photos:
8 X 10 B&W In our files

snapshot
Bibliography:
Willsberger, Johann. The History of Photography. Il. p. 67.
Ashton, Gloria. "New Work Holds Surprises." Col. il.
Exhibition History:
Basel Kunsthalle, 1972. Cat. # 58
Museum of Modern Art, 1979. Cat. # 3

Provenance - Location	Dates	Notes
Ronald Loogar,		
Buchwald and Company	5/1090-6/1/90	
Hugh de la Ville	3/4/85-3/21/90	

Appraiser	Date	Value	Notes
Shelly Howell, Sheridon	12/22/95	12,345	Here are some appraisal notes.

**FIG. 12.3 A PRINTOUT OF ALL INFORMATION TYPED IN
THE ARTWORK ENTRY FORM**

print information in tabular (column and row) form,
so that many artworks would be listed on a page.
Yet another report could print basic information on
slide labels. An additional design aid found in many
database manager applications are predefined report
layouts based on brand name labels, such as those
made by the Avery Dennison Corporation. Self-
adhesive labels of every needed size, as well as
perforated rotary file cards and loose leaf agenda
pages, are available in 8 1/2 x 11 inch sheets—the

size that works best with most computer printers. Reports can be based on queries to print only specific records, creating a powerful combination.

A good database manager will also include printed or onscreen documentation and instructions for use. The documentation should be in plain English—clear and easy to follow and well indexed.

Additionally, there should be some way to output (export) the data in digital form: essential when the time comes to update to a new database manager, so that the data doesn't need to be typed in again.

Checklist

Essential Hardware
- ❏ Computer
- ❏ Monitor
- ❏ Keyboard and mouse
- ❏ Printer
- ❏ Surge protector

Essential Software
- ❏ Operating system
- ❏ Database manager
- ❏ Backup utility program

Database Components
- ❏ Tables with fields to store each category of data
- ❏ Forms to view and add data
- ❏ Queries to find and sort data
- ❏ Reports to print out data
- ❏ Printed or onscreen instructions, documentation, and help
- ❏ Digital export capabilities

Maria Reidelbach is a computer consultant, private registrar, and archivist with an international clientele of artists, art collectors, foundations, and scholars. She lives in New York City and has written instructional books for Microsoft Access, Works for Windows, and WordPerfect.

Interviews with the Experts

by Ann Craddock Albano

Advice from the Experts

The roots of preservation date back to ancient times, when cultures discovered that safeguarding and maintaining objects is vital to the continued development of civilization. Today, at the dawn of the twenty-first century, the objects of civilization have become increasingly diverse (Iris prints, Gortex apparel) and increasingly ephemeral (TIFs, GIFs, JPEGs). The plethora and insubstantiality of new Millennium art and storage materials bring new methodologies and technologies to the field of art maintenance. This chapter offers up-to-the-minute perspectives on caring for your art from five widely respected experts.

Private conservators Barbara Appelbaum and Paul Himmelstein comment on the best environments for displaying and storing art. Merv Richard, conservator at the National Gallery of Art, recommends superior methods for making sure works that travel are properly packed and transported. Eric Fischer, Vice President of the company Fine Arts Risk Management, explains the latest developments in fine arts insurance.

New challenges confront conservators faced with preserving works of Modern and Contempo-

rary art, which are showing their age because of the experimental and unstable substances used in their construction. Albert Albano, Executive Director of the Intermuseum Conservation Association, provides the latest insights into dealing with deteriorating materials. Finally, Andrew Robb, photograph conservator, discusses stability and preservation issues as they relate to all display and storage media for the art photograph: from the traditional gelatin silver print, to the latest digitally captured, PhotoShop enhanced, electronically stored image.

Environment and Storage

Barbara Appelbaum and Paul Himmelstein, Conservators in Private Practice

Q. People are often unclear about the degree to which they should go to preserve their art. Can you give any further advice on this dilemma?

A. Before we get into details about environmental control, it might help to discuss the ways in which people can deal with these problems in general. There are no magic answers when it comes to caring for one's artwork. The way that an artwork can and should be preserved varies depending on the materials, construction, and history of the specific piece of art. What can and should be done also depends on the value and rarity of the artwork, the resources of the owners, the type of building in which it is housed, and other such variables.

Artists have multiple roles in the preservation of

their work. Obviously, the way a work of art is made has a lot to do with its physical needs and susceptibilities. Most artists have many of their own works in some kind of storage. Artists can help preserve their own works by keeping records of materials and techniques and passing that information along to new owners. Conservators are sometimes surprised at the carelessness with which some artists treat their own works, although we try to remember that the act of creation and the sober work of preservation of those works embody very different motivations and habits of mind. Perhaps artists should think of preservation as an investment in the future that has both financial and emotional aspects.

One of the things that owners—and this includes artists—can do is to become familiar with the condition of their objects. If paintings or works on paper do not stay flat after a few months or longer, the environment and technique may need to be changed. If the work stays flat, fairly consistently, then the relative humidity is probably fine, or at least good technique overrides any problems. For artists, monitoring the condition may involve looking at their work in a new way; good quality photographs and good record keeping make this easier.

Ideally, owners should have a conservator look at their possessions and educate them about the condition and susceptibilities of individual pieces. They should be aware, however, that conservators vary widely in expertise about climate control, lighting, and materials used by the artist. Conservators, like other professionals, are increasingly specialized; although most conservators can provide useful information on a variety of objects,

they may need to refer to other conservators who deal more with environmental issues. Once a conservator has seen a collection and the space that holds the art, and talked to the owners about their use of the collection, most questions can be answered on the telephone, making the subsequent cost minimal. Good advice is worth the expense because it can prevent serious problems later.

Likewise, artists who would like to discuss technical issues with conservators may have to make a few telephone calls before finding the person who is experienced in this area or willing to acquire the necessary information, as well as being willing to work with them in a mutually supportive way. In some cities, artists have gotten together to discuss technical concerns, and have invited conservators and other professionals in the materials, packing, and insurance fields to speak to them and answer questions. This can be very helpful, and at a relatively low cost.

Q. How do you respond to collectors or curators who say their artwork has been in an uncontrolled environment from its creation, so why worry about it now?

A. Aging causes most objects to become more fragile and more sensitive to the environment over time. In addition, when many kinds of objects were new, their owners expected to throw them out when they became worn. For those old things that have somehow escaped that fate, we may now want to preserve for at least our grandchildren. If we want some of our possessions to last forever, we have to treat them differently. Conservation

tries to maximize the owner's enjoyment while assuring that future generations continue to have the same opportunity.

Temperature and Relative Humidity

Q. How do you feel about the stricture to keep conditions to 70° F and 50 percent relative humidity?

A. If someone tells you that your collection should be kept at 70° F and 50 percent relative humidity, do not believe him. This is not necessary, and in many cases, not even beneficial. Works that have been kept in a different environment can become damaged by placing them in a 70° F, 50 percent relative humidity environment. The humidity may be too high for many metal objects and promote corrosion, and paper actually lasts longer at lower relative humidity levels. A comfort level of 70° F is best for people, but not so for objects. Most objects last longer at much lower temperatures. Broadly speaking, artwork is more sensitive to relative humidity than temperature. Temperature, in an absolute sense, is important because higher temperatures accelerate chemical reactions, including those that contribute to deterioration. Temperatures in the ranges that are comfortable for people, and much lower are perfectly fine. Organic objects last longer at lower temperatures, but there are very few situations where cold storage is a practical strategy. Extremes of temperature should be avoided. Higher temperatures can cause varnishes, finishes, and some media to soften and become tacky. Acrylic paintings and oil paintings can crack when suddenly exposed to

the cold, as might happen during shipment. Temperature is most relevant to this discussion because it can cause changes in relative humidity. In a closed room, when the temperature goes up, the relative humidity drops, and when the temperature goes down, the relative humidity rises. Thus, in the winter, you can simply lower the temperature in a space from the usual 74°F to 65°F, which many people actually find more comfortable; this raises the relative humidity quite a bit, and is beneficial to most works of art.

Unlike people, objects are more sensitive to relative humidity than to temperature. Heat from a radiator or direct sunlight, for example, is harmful primarily because of its effect on the room's humidity level. In general, the extremes of relative humidity are most harmful. High humidity in the summer, and the very low humidity caused by heating in the winter, can be harmful to artwork. High humidity promotes mold growth and corrosion of metals, and very low humidity makes many materials brittle. The goal is to avoid the extremes—below about 30 percent relative humidity and above about 70 percent relative humidity and keep the humidity as steady as possible.

Rapid temperature and relative humidity fluctuation can cause damage to certain objects, including painted wood, fragile ivory, parchment, and stretched paper. Wide relative humidity fluctuations cause wood to crack, and paper to expand and contract, which in turn causes the paper to alternately flatten and ripple. This usually does not cause damage unless the paper is restrained and tears or has a heavily applied medium that could crack. Paintings on canvas are also adversely affected over time. Canvas expands and contracts

with wide swings of relative humidity, causing cycles of tightening and loosening of paintings on their stretchers. This eventually results in cracked paint, and a permanent distortion of the canvas. Problems to stone and ceramics from relative humidity fluctuations are comparatively rare, and mainly occur in archaeological objects.

Q. Are there any objects or artworks that really need to be kept in a more closely controlled or different relative humidity?

A. In addition to the categories of objects mentioned, certain individual works can be unusually sensitive for reasons that are difficult to discern. Recurring problems, in spite of competent treatment, do happen and a conservator should definitely be consulted.

Q. How much protection from environmental fluctuation does a closed exhibition case or a frame with glazing and a backing offer to artwork? Do the enclosures help smooth out the sudden change of condition?

A. Containerization slows down changes in relative humidity and provides other protection as well. Glass cases or archival boxes, which include alkaline buffers, are very helpful. Backings for paintings offer similar protection, and also make it much safer and easier to store the paintings; backings should not, however, have corners or other holes cut in them.

The traditional matting and framing of paper is a very powerful method of protection, particularly if ultraviolet-filtering acrylic sheeting is used instead

of glass. If buffered paper materials are also added to the package, they can help to counter-act acidic off-gassing. This minimizes the need for frequent removal of the work from its frame, and reduces opportunity for damage.

Q. Do you recommend putting the most vulner-able or valuable part of a collection in a room where special measures have already been taken to keep a more stable environment?

A. This kind of decision needs to be made after consideration of the particular situation. One would think, for example, that a valuable collec-tion of ancient or medieval ivories would warrant a specially designed space, but this kind of thing makes no sense in households where families enjoy seeing and touching the things they own or where artists want to refer to their past work frequently. However, certain fragile family items should probably be protected from too much love. It all depends.

Q. Are there problems unique to collections that are left in an unheated storage unit or summer-house during the winter, or kept in a humid environment such as in a house by the seaside?

A. Unheated spaces are really quite good for the preservation of most objects. Objects do not suffer from cold, and the relative humidity is much steadier in spaces without winter heating. The problem is that many unheated spaces are not properly maintained or supervised so leaks, infestations, and other disasters can occur. In addition, in winter relative humidity in an un-

heated space can become quite high, leading to mold growth. Good air circulation can help this problem. Seaside conditions encourage mold growth, but for many objects, steady high humidity may not be as harmful as widely fluctuating levels, as long as there is sufficient air movement. It is important to inspect an art collection that is stored in either type of environment, so that problems can be dealt with before they get worse. An object that is a potential victim of water damage should at least be draped with plastic. More protection is better, since you never know when it will be needed. In most cases, minor changes can help prevent problems, so consult with a conservator in advance and prevent a more costly consultation later.

Light and Lighting

Q. Many people believe that if they have ultraviolet filtering film on their windows or ultra-violet absorbing glaze over their artwork, they do not need to worry further about light levels. Is this true?

A. No. Although ultraviolet light causes more deterioration than visible light, it should be removed because it has no positive effects; visible light also causes deterioration, particularly on very sensitive things like photographs, silk fabric, and watercolor paint.

Q. Are all materials that constitute artwork or historic artifacts affected by light in the same way?

A. No, motion-activated lights are sometimes used to raise levels a little when visitors are in a gallery, but this is often not practical. Motion-activated lights require elaborate hardware. They provide no advantage in a gallery that always has people in it, and some people find the effect kind of spooky. A good lighting company to know about is NOUVIR, 20915 Sussex Highway, Seaford, Delaware 19973 302-628-9933.

Q. Which materials are most affected by light and are there materials that a collector does not need to worry about?

A. Textiles, particularly silk, acidic paper, water-colors, and colored photographs are most notice-ably affected by light. Black and white works on paper are less susceptible. Oil and tempera paint-ings and wood are in a middle category. Wood can become either bleached or darkened by light exposure, and the finish can also be affected. Most ceramics, metals, and stone are virtually unaffected by light. Colored photographs are not stable even in the dark, so their preservation is a more complicated matter. Most plastic materials are quite susceptible to light damage. It should be noted that although fading is the obvious hazard of light exposure, light also causes chemical deterioration of textiles, paper, and plastic.

Q. Often art is exposed to a high light level when it is in an artist's studio, or on exhibition at a gallery, but is properly cared for by a collector or museum. Does it matter if sensitive artwork gets a tremendous amount of light initially, but then little light exposure later?

A. The effects of light are cumulative. A particular amount of light falling on an object for a year produces the same changes that half the amount would produce in two years. It all adds up. There is a change in sensitivity as an object ages. Bright colors may fade more quickly at first, but the details are very complicated and depend on the chemistry of the individual materials. Limiting light exposure is a protective measure; we cannot predict exactly what will happen to an individual object. Given the hopefully long history of a work of art, the relatively short time that art is exposed to high light level in an artist's studio or gallery is relatively inconsequential. It is still better to avoid unnecessary exposure at times when no one is in the studio or when the gallery is closed.

Q. What light levels, length of exposure, and lamping types do your recommend to your clients for their collections?

A. This is a complicated question, because an effective lighting scheme does not depend solely on the amount of light. More light does not necessarily make things look better and dimming light without making other changes is likely to produce unsatisfactory results. You must also consider the color and reflectivity of the walls, the brightness of adjacent spaces, and reflections from other surfaces in a room. All of these variables can have a huge effect on the appearance of a work of art. Lighting designers who are not familiar with lighting techniques for the purpose of art conservation may produce systems

that are harmful. There is no easy answer.

Many people like track systems because they accommodate a variety of fixtures; and some fixtures have space for light filters. Fiber-optic lighting is a wonderful development because it is extremely adaptable and energy-efficient. It is also very low maintenance, which is important for small museums and private owners. Lighting designers in the United States are beginning to use fiber-optic sources, already quite common in European museums. Fiber-optic systems are more difficult to install and they are also more difficult to use properly.

Q. Most artists and institutions know to exhibit light sensitive materials for only short periods of time under low light. What should an artist or institution do if it keeps getting requests for exhibition or loan of the same light sensitive artwork?

A. Museums have loan policies that require certain levels of temperature and relative humidity, light, and security, but to be honest, these are not always realistic, and loans often create problems. Artists and owners have many reasons to agree to loan their works, so it is understandably difficult for them to say no. A loan situation is where a conservator can offer good guidance. A conservator can query the borrower and help the lender establish appropriate requirements. The conservator can also provide assistance with framing and packing so that the work is protected as much as possible, and can evaluate the artwork's condition upon its return.

Q. How should an institution deal with a light sensitive artwork or artifact, such as a watercolor

or textile, if it is one of the most important pieces of the collection?

A. Limiting the duration and intensity of exposure can be very beneficial. It has been estimated that in museums open to the public for six days per week, about one third of the exposure occurs when the museum is closed! Motion-activated lights are some-times used to raise levels somewhat when visitors are in a gallery, but this is not often practical.

Q. Do you believe that facsimiles are appropriate in certain situations?

A. Yes, particularly facsimiles of historic houses; color photocopies of important documents may be the best way to deal with this problem. They can produce incredibly accurate-looking copies.

Pollutants from Outside and In

Q. Do you often encounter pollution damage from the off-gassing of materials such as carpeting, paint, flooring, or construction materials such as particle-board plywood and other case materials, or concrete floors?

A. Many museums have had damage of this kind, but it is not common elsewhere. The worst prob-lem of this kind occurs mostly in sealed exhibition cases or rooms with low ventilation. This is not as common in a home as it is in a museum. Dust is more of a problem for private owners and artists, as repeated cleaning can cause substantial dam-age. Dust settling on wet paint is obviously a

problem in an artist's studio.

For artists, the main difficulty is the construction of storage furniture, because storerooms are apt to be closed and as a result entrap potentially harmful fumes. If private owners are having cases made, they need to carefully choose construction and finishing materials that block the action of pollutants. The topic of construction materials gets quite complicated. For example, different grades of plywood are made with different adhesives—the kind of plywood labeled as marine plywood is less acidic than other kinds. Coating boards to prevent acids in wood products from coming out may make the situation worse. Because of the variety of available products—boards, paints, and coatings—this matter should be referred to a professional. Asking advice in advance can help avoid spending a lot of money on something that turns out to be a mistake.

Storage for the Overflow

Q. You often receive questions from artists, dealers, collectors, and smaller institutions about storing the artwork that they are not currently displaying. This book gives excellent suggestions for storage units and boxes that can be purchased or built from stable materials. Do you have other practical suggestions on the qualities to look for when researching off-site, away from home storage systems?

A. Environmental issues are of course important, but practical matters like making sure that things don't get bumped, jostled, or broken and that they

are well labeled are just as important. In basements, everything should be stored at least six inches off the floor, in case of flooding, and you should be very concerned about excessive humidity. In an attic you should be wary of leaks and the deteriorating effects of very high heat.

The most important requirement is a clean, well-maintained space that will keep the rain out, and that can be inspected periodically. Out of sight, out of mind definitely applies. Security is of course vital, as is good record keeping, and a reliable, knowledgeable, and cooperative staff. You need to remember that space appropriate for long-term storage of valuable objects can be substantially more expensive than space used for ordinary household belongings.

Preparing Your Art for Transport, Transporting Your Art Safely

Merv Richard, Conservator, National Gallery of Art

Q. We know the advantages to wrapping works before placing them in a packing case, but can the wrapping materials cause problems?

A. Wrapping materials that come in direct contact with the surface of an artwork can cause damage. Creases in paper or glassine, for example, can scratch delicate surfaces and some materials even adhere to tacky finishes. The latter problem usually occurs as a result of wrapping works of art before the paint or varnish has dried, but it also happens if the paint or varnish becomes tacky when exposed to higher temperatures during shipment. Some substances never dry and, therefore, nothing should come in contact with their surfaces. For example, a number of Abstract Expressionists experimented with paint media that remain tacky to this day. Removing paper or plastic adhered to their paintings is difficult and can permanently alter a work's surface texture. A slightly different problem results from packaging that chemically affects works of art. Wrapping materials and storage bags made with high-grade polyethylene are usually inert, but other products made with polyvinyl chloride or polyvinylidene chloride, often used for household storage bags and some bubble wrapping, can damage objects. Vapors emitted by these materials can actually etch the surface of artworks and even leave a pattern of the bubble wrap on the surface of a highly polished metal sculpture.

Wrapping artworks with plastic sheeting, such as polyethylene, poses additional risks. Hygroscopic materials—wood, paper, fabric—absorb and desorb moisture with variations in ambient relative humidity. If the artwork is in an environment above 70 percent relative humidity, as might well happen in the summer or in the tropics, there is a real risk of condensation and mold growth, and it is better to wrap the work with paper or glassine. On the other hand, when works of art are in lower relative humidity levels, as is the case in most museums or in many places during the winter months, wrapping them in polyethylene sheeting is recommended.

Q. What particular precautions should be taken when transporting paintings in a truck or aircraft?

A. To prevent shifting or falling, packing cases should be tightly secured to the side walls of a truck. To minimize vibration, paintings should stand vertically with the plane of the painting aligned in the direction of travel; paintings should never be transported flat. A backing board attached to the back of a stretcher or frame can significantly reduce harmful vibrations. In the rare event that it is necessary to transport a very large painting at an angle, a foam or polyester batting should be carefully laid against the back of the canvas to provide support. Painted canvases should never drape over or hit against the stretcher bars as this can cause cracks or loss in the paint layers.

When high value artworks are transported on airplanes, a courier who oversees handling operations during transit usually accompanies the

packing cases. Airline personnel secure the cases onto palettes or inside aircraft containers. You should anticipate less careful handling when artworks are sent via commercial, non-fine arts shipping companies. Assume that small packages will be placed in trucks, and that an aircraft cargo hold has no provision for securing your work. Unfortunately, arrows painted on packing cases will rarely ensure that they travel in the desired orientation.

Q. Are there any new recommendations for materials and techniques used for packing works of art?

A. Although there have been no major developments in recent years, we have seen a general improvement in the quality of packing. Museums, as well as professional organizations and commercial transport firms, have been the impetus behind this rise in standards.

The recommendations provided in *Caring for Your Art* are still applicable with only a few minor qualifications. The book focuses on the use of polyethylene foam as a cushioning material. High-grade polyethylene foam is regarded as safe for museum objects and, therefore, is an excellent choice. High-grade polyurethane foam, especially the ester type, is practical and safe for packing cases; it should be used, however, for relatively short periods of exposure. I must stress that these materials should by no means be used for long-term storage, as they emit vapors that can damage works of art.

Potentially harmful vapors are also emitted by solvent-based polyurethane varnish and oil based paints. The book recommends using them to seal

wooden packing cases, but these substances require weeks to completely dry. That being the case, it is probably safer to use exterior latex paint or waterborne polyurethane varnish as a sealant. You can also line packing cases with plastic sheeting, metal foil laminates, or other waterproof materials and avoid the paint problems all together.

Q. Don't you think artwork shipping in mailing tubes, specifically art on paper, needs more discussion and clarification?

A. Of utmost importance in deciding whether or not to use a mailing tube, is an assessment of the artwork's significance, including its rarity and worth. I would not, under any circumstance, ship an important work in a mailing tube, no matter how well it met my criteria.

Before sending a work in a mailing tube, the suitability of the paper and the medium has to be evaluated. If the artwork is made with pastel, charcoal, heavily layered graphite, or other friable media, the packing material should not come into contact with the work's surface, because the media can so easily lift or smear; and you should always place the artwork in a sink mat or shallow box. If possible, the work should also be held in place at its outermost corners only, and shipped in a horizontal orientation.

Stiff papers should never be rolled. Any thick medium, such as heavily applied gouache or certain brittle printing inks, as well as photographs on stiff paper or with a baryta layer, should not be rolled, since this can cause cracking of the medium or baryta. If there is any chance that the

medium might stick or transfer onto the adjacent paper, the artwork should not be rolled. As a precaution, even if the medium has been carefully evaluated, most people always roll the artwork with a cover sheet of glassine.

If unmatted artwork is on a flexible paper support and its medium will not transfer or crack, it can be rolled and shipped in a mailing tube. One potential danger of rolling artwork for shipping is the likelihood of damaging the work in the process of removing it from the tube, especially since rolled works tend to expand and conform to the contours of the tube. Another risk is the possibility that the recipient may leave the artwork in the tube for a prolonged period of time, thereby causing the work to curl. In the event that the paper does curl, flattening it often requires humidification, and may pose some risk of damage.

You can minimize the problem of extricating the artwork and give it additional support by rolling it onto a smaller tube first, and then securing the roll. The artwork can be firmly rolled, with or without a cover sheet, onto a lightweight tube of a smaller diameter than the outer tube. The roll should be fully covered with a protective sheet of paper and secured with ties of cotton twill tape, or bands of paper that are held together with pressure sensitive tape. When using pressure sensitive tape, fold back one end onto itself to create a tab. That tab will allow the recipient to pull the tape away without applying pressure to the artwork. Never use rubber bands to fasten the roll because they can easily cause indentations in the paper. If an inner tube is not available, the artwork can still be rolled, covered,

and secured as long as the diameter of the roll is less than that of the mailing tube. Additional bubble wrap can be placed around the roll to prevent it from moving in the tube.

The ends of the artwork should be carefully padded in the mailing tube for extra protection to the edges. If the mailing tube is thick and sturdy enough to sustain relatively rough handling, it can be sent by the United States Postal Service, United Parcel Service, or Federal Express. It is safer to entrust very large or insubstantial tubes to a fine arts shipper.

Fine Arts Insurance

Eric Fischer, Vice President, Fine Arts Risk Management, Arlington, VA

Q. How does a neophyte find a listing of fine art insurers and what criteria should you use to compare the different companies? Does it help to get a referral and vote of confidence from another artist, dealer, collector, or institution that is already with a company?

A. The best way to look for a fine arts insurer is to look in art-related periodicals for ads, search the Internet, contact the local museum, ask fellow collectors, artists, or your local agent to contact a fine arts specialist to place your coverage. Your broker or agent should use the best companies to place your business. All companies are rated by AM Best according to financial strength and capacity. A company is measured on a descending scale from A++ and A+ (superior) to S (suspended) for financial strength, and an ascending scale from FSC 1 to FSC XV (financial size categories less than 1 to greater than 2,000) for financial capacity. The company should be at least rated A-V. Companies like Travelers and Kemper are rated A-XV.

As far as the performance of the broker, the best way to check on it is to ask the broker for references, and seek opinions from fellow artists and collectors. When bidding out your insurance needs, ask for references from the broker, and ask for references from those who have had claims. Referrals are the best way to find a good broker or agent.

Q. Should an artist be looking for a different set of criteria and type of company than a gallery, collector, or small institution?

A. An artist should be looking for a broker or agent who recognizes that artists' needs are very much different than those of a gallery or collector. Often, a specialist fine arts insurance broker will have a staff with expertise in each area.

Q. Does it matter if the company is not located in your immediate area?

A. There are several reputable fine arts insurance brokers who work on a national level. However, your local broker will often have access to the same insurance companies as the national brokers, and they can service your account just as well, as long as they are familiar with the special needs of the arts community.

Q. How do you find out if a fine arts insurance company is reputable and settles claims fairly and equitably?

A. As far as paying claims fairly, each state has an insurance commissioner who maintains listings of unfair claims settlement practices. That person should be contacted if there is a question. However, the fine arts insurance market is, overall, very reputable and pays claims.

Q. Do insurance rates vary widely within the industry? How does a fine arts insurance company determine what your rate of insurance will be? Is it based on the number of claims in your geographic

area, as is done in the automobile insurance industry? Or does the fine arts insurance industry base rates on the type of art that you make, sell, or collect, your security arrangements, how often your artwork travels, and other such factors?

A. Rates can vary depending on the broker or agent one uses and the company that writes the insurance. It is always best to obtain three quotes when looking for insurance. The insurance market place for fine arts is very competitive—it pays to look around.

Most premiums are based on the overall values at risk. The rate that is charged is based on many factors including the type of object in the collection, security of the building, construction of the building, previous loss history, fire suppression and detection system, experience with collecting art, and whether the art is moved on a regular basis. Rates for fine arts insurance are not based (like auto insurance) on an experience factor in a given area, or within a certain age range. The previous experience of the individual or institution is far more important. Other factors include earthquake exposure, hurricane exposure, risk of flood, and other natural catastrophes.

Q. When should an artist or a collector change from homeowners insurance with an itemized fine arts rider to fine arts insurance from a company such as yours?

A. Individual collectors should look at moving from a homeowner's policy to insure their collection to a specialist policy once their collection starts to enter the $1 million valuation area. At

this point, one should compare price, coverage, and flexibility of coverage to meet one's need. Consider changing when you feel that the current homeowner's policy is no longer able to meet your needs (i.e., the policy becomes too restrictive, especially if you are collecting more and more). If a collection does not move, and there is little in the way of new acquisitions, then the homeowner's policy still may be the best option. A specialist of fine arts insurance policy provides much broader coverage than a homeowner's policy, especially in terms of providing transit coverage and greater valuation options. Many policies now offer coverage at 150 percent of the scheduled value, in case the value of the item increased since the last appraisal. Fine arts insurance is all risk, with very few exceptions, so the policy must be extremely flexible, allowing the collector to move works from place to place without having to call for a special transit coverage, as is required by many homeowner's carriers. Some homeowner's policies are very reluctant to insure when there is movement of large value items. Specialist brokers often have their own manuscript policy (not available to other brokers), so there are advantages to taking a look at what they have to offer. Collectors should consider updating their appraisals every three years.

Q. Are there certain critical terms and stipulations that you should be looking for when evaluating fine arts insurance?

A. The main points of any fine arts insurance policy are 1) exclusions, 2) type of artwork or

object covered, 3) basis of valuation, 4)
deductibles, 5) conditions of insured, which is
what the insured must do to maintain a valid
policy, and 6) limits of coverage.

Q. Does a fine arts insurance policy stipulate the
type of storage, security, transportation arrange-
ments, environmental controls, and the like that
the insured must maintain and follow? May the
insured assume that he or she makes the decision
on any of these matters if there is nothing stipu-
lated in the insurance contract? Or should you check
with your agent when you feel something slightly
out of the ordinary is happening to your artwork?

A. It depends on the policy. Some policies do in
fact have alarm requirements, shipping and
packing requirements, and other conditions that
the insured must follow to maintain the coverage
in force (read your policy). If there are no condi-
tions stated in the policy, the only requirement is
that the policy holder acts as a reasonable and
prudent person would act in a given circum-
stance. It is always best to get clarification in
writing from your broker or agent on any question
that you have regarding coverage, especially if
there is not a clear answer found in the policy.

Q. Is there any way to determine the insurance
value of an artwork other than by the bill of sale,
or the evaluation of a paid appraiser, whose
services can be quite expensive? If you follow the
art market carefully, may you establish value by
sale or auction of a similar piece? Is it acceptable
for an artist or gallery to write a letter stating the
current retail value of an artwork?

A. Valuation is a difficult topic to lump together. Bills of sale and current appraisals are the most common way of determining value. Insurance companies are requiring more and more that collectors supply these as proof of value. For artists, recent sales history can be a good indication of the current value of their work. If there is a question, insurance companies are very open-minded about finding the fairest way to determine value. Recent sales at auction are a good indicator of value, but most people do not have the time to follow every sale. Having said this, many appraisers now offer to update a collector's schedule automatically, through computerized inventories. If you are building a sizable collection, you may want to look into a service such as this.

Q. Outline the steps an artist, gallery, collector, or small institution should take if an artwork is damaged or stolen. Who should be contacted and in what order? What documentation should be made of the event? What records should be kept? How long after damage has occurred may a claim be made?

A. If an item has been stolen, contact the police first. Then contact your insurance broker, agent, or claims office depending on your insurance arrangement. You should ask if your insurance carrier has an arrangement to place the stolen item on the Art Loss Register or another similar international database of stolen items.

Any and all documents that you have are important in the event of a theft. They help prove that you in fact owned the object, and they will also assist the police by providing an accurate descrip-

tion of the item. Copies of bills of sale and recent appraisals should be kept at a secondary location such as a safety deposit box in the event of a loss. The more documentation you have, the smoother the claim settlement process will go.

Turn in claims to your insurance company as soon as possible, or as soon as you discover that an item is missing.

Q. Everyone knows that your automobile insurance rates go up if you have an accident of any magnitude, even if you did not cause the accident. Is it the same with fine arts insurance? Do you have to be very selective in the claims that you make so that the insurer will renew your policy at a favorable rate? How does a fine arts insurance company view the human carelessness factor, such as leaving an artwork in the trunk of a car in New York, and having it stolen? Is this a mark against the owner?

A. Increases in fine arts insurance rates are much more subjective than with auto insurance. Not all who have claims get increases—some do, some do not. It really depends on the circumstances surrounding the claim. If you act in a careless way and claim a loss, an insurance company may not wish to insure you, and may ultimately give you notice of non-renewal or cancellation. Insurance is there to pay covered causes of loss. Most policies contain deductibles to eliminate smaller claims and keep loss records free of these tiny claims. It is really a personal decision to turn in a claim if it is small.

Q. Our fine arts insurance underwriter sent an

agent to evaluate all the safety practices of our institution, and requested that certain changes and improvements be made. Is this a common practice in the fine arts insurance industry?

A. Most insurance companies will ask to survey your location to ensure that you are protecting your art as you had stated in your application.

Q. May the insured request this evaluation or refuse to comply with the request of the under-writer or insurer?

A. If the loss control survey has recommendations for the insured, the insurance company will ask that these recommendations be complied with. If the recommendation is not something that the insured can complete or feels is not necessary, he can of course appeal to have the recommendation removed. But the underwriter must agree to re-move this recommendation or the insured runs the risk of having the policy canceled for non-compli-ance of a condition. If the insured does not com-ply with the recommendation and a loss occurs as a result of this failure to comply, the insurance company will probably deny the claim.

Q. Are there other or new ways of protecting artwork that you recommend that are not covered in the earlier chapters in this book?

A. I cannot think of any new ways of protecting art.

Q. What is a reasonable amount of time to be prepared to wait for reimbursement after an insurance claim is made? How do you determine if an insurance

company is stalling or taking advantage of you?

A. Once all the paperwork is sent to the insurance company including proof of loss, you should expect a check within two weeks. However, a fine arts loss claim can take some time to settle, three to six months is common. The fact is that most losses are not clear-cut, and often the opinions of many experts are needed before the claim can be settled. If you are not getting any response to questions, especially if you have supplied all the necessary paperwork, you may be getting the run-around. But most claims take a long time to settle because the claimant or other involved parties did not submit all required paperwork.

Q. If you are an artist and a catastrophe destroys your studio and all your materials so you cannot make art, what provisions does an insurance company immediately make to get you on your feet as quickly as possible so that your livelihood can be pursued?

A. This question involves several different types of policies—property, fine arts artists or dealers policy. The property policy should provide the coverage to help find a temporary location for the artist to use as a studio as well as to provide for the artist get new materials while the old location is being rebuilt. The fine arts artists policy will respond to finished works that may have been in the studio. The artist will have to prove that these works were in fact there at the time of the loss. Therefore good documentation and meticulous record keeping is advised.

Q. I know an insurance company will go after the

insurance company of another party if they feel that the other party caused the damage. When that happens, is the insured person who has suffered the damage obliged to wait for reimbursement until the dispute is settled?

A. If one insurance company looks to another insurance company for reimbursement for a loss, i.e., subrogation, the initial insured party does not have to wait for settlement to be paid. He will, however, have to wait until the case is finally settled to get back the deductible.

Q. How does an insurance company determine reimbursement for an artist, gallery, collector, or institution if an artwork is damaged, destroyed, lost, or stolen?

A. Most insurance polices have a valuation clause which states how the value of an object will be determined in case of loss. There are two types of valuations: 1) agreed value or scheduled, 2) current market value. If an object has an agreed value, and it is a total loss, the insurance company will pay the stated amount. As I stated earlier, some policies have a 150 percent of agreed value to compensate for fluctuations in value, since they only require an updated appraisal every three to five years. Items insured at current market value are handled a bit differently.

Q. How does an insurance company decide if a damaged work of art has permanently lost value, even after conservation? How does a company decide if a damaged work of art should be declared ruined beyond conservation, and if the owner

should receive a full reimbursement?

A. Should the item be a total loss, then the adjuster, working in conjunction with appraisers, comes up with a value of the object at the time of loss. Should the owner of the object not agree with the value, then the policy should have an arbitration clause to guide the two parties through the dispute. In the arbitration phase, each side chooses an expert to determine the value. Should no agreement be reached, both parties pick a third person to act as the arbitrator in the dispute.

Q. What happens to artwork and who owns it when it is declared totally ruined?

A. Once an object is declared a total loss, the salvage of that item becomes property of the insurance company. The company may try to re-sell the damaged item, offer the item back to the insured at the salvage value, or simply destroy what is left. The Visual Artists Rights Act (VARA), passed in Congress in the early 1990's, protects the living artist on "rights" to works created, which includes the artist's right to "request destruction" of damaged artwork, if he thinks the work is too altered, even after restoration.

Q. What efforts do insurance companies make to try to locate stolen works of art?

A. If a work is stolen, almost every insurance company will report the item stolen to the Art Loss Register, a group that lists on the Internet all stolen works of art reported to them if the work is valued over $5,000 (www.artloss.com). Of

course, any work should be reported to the police. Once an object is recovered, the owner may buy it back from the insurance company for the settlement value.

Q. When is it safe or fiscally advantageous for you to have another person assume the insurance responsibility for your artwork when it is on consignment to a dealer, collector, in an exhibition, or in the hands of a shipping company?

A. The question of who should provide the insurance when an object is moved from its normal place of deposit is a complicated one. Some people or museums insist on maintaining their own insurance regardless. They know their policy and do not want anyone else insuring their object. More often than not, however, the borrowing entity will provide the "wall to wall" coverage while it is away from its home, especially in the case of a museum. The real question, in my opinion, is who derives the greatest benefit from the movement of the object? Who ever gets the greater benefit should provide the insurance. In the case of an artist this may prove to be quite difficult, and he or she may ask the larger entity i.e., dealer, museum, or gallery to provide the coverage.

Q. How can you confirm that the person (or entity) who accepts responsibility for the insurance has good coverage, and that you will be guaranteed proper reimbursement for damage or loss?

A. Whatever the case, the lender should always

seek a Certificate of Insurance from the borrower. The Certificate should list the item with its value, the exclusions found in the policy, the policy number, name of insurance company, and dates of coverage. Ask your broker or agent to review the document to ensure that all is in order. Your broker or agent will be able to tell you if you have the insurance you need for the purpose of lending. The most important document in any situation is the Loan Agreement. This contract will spell out the terms and conditions of the loan or consignment and should clearly state who is providing the insurance. The Certificate is just a confirmation of the insurance. If artwork is being sent abroad, make sure that the insurance for the work includes international coverage. Most policies cover works in the United States and Canada, but do not cover works outside of these two countries.

Q. How should you handle insurance if your artwork is going abroad for sale or exhibition if you do not have international coverage?

A. Insurance policies from foreign countries can be quite different from American policies, and policies within a country may have vary considerably on terms. If a foreign entity offers to insure your artwork, it is best to ask for a copy of the policy and review it carefully with your agent or broker to be certain that all risks are fully covered.

Q. Artists who work in group-studio buildings seem particularly at risk. How does an artist evaluate a rental contract, so that he is protected,

in the event the owner of the building becomes liable, because of a defect in the building—a leaky roof or window, a broken pipe or radiator, or sloppy maintenance work—and has to pay for the damages?

A. An artist in a single studio or group building must read the rental contract very carefully. If there is no mention of the insurance carried by the landlord, the artist should ask that this be added to the contract with the coverage clearly stated. The artist needs to obtain his own insurance to protect his property and to cover his liability. In addition, he may also want to consider purchasing an artist's fine arts insurance policy. Should damage happen to either his property or his completed works of art, the artist's insurance company will pay the artist for the loss, and look to the responsible party for compensation, such as the building owner or other parties who caused the loss. As with any policy, there are exclusions. Read them carefully. Work with your agent or broker to understand the policy and obtain the best policy that suits your needs. Don't assume that the standard policy is best for you.

Q. Are there circumstances where an artist, acting prudently and carefully, can still be held responsible for damage to another's artwork because, say, the plumbing in his rental area overflows and damages another's artwork?

A. Your general liability insurance will protect you from acts you commit that damage other people's property. Again, work with the agent or broker to ensure that the policy fits your needs. Building

code violations are often excluded in property and liability policies, both the owner's and the artist's. Be sure to check and understand the policies and exclusions. You can always purchase additional coverage to fill the gaps. If you do, ask for an amendment to your rental contract, in case of gaps in the landlord's policy.

Conclusion

Q. Do you feel that everything we have discussed is applicable to an artist, gallery owner, collector, or small institution, no matter what the value of the artwork or collection? Or should other factors, perhaps beyond the scope of this book, be taken into consideration as the retail prices and insurance values of the artwork escalate?

A. I would approach insurance on two different levels: 1) coverage for the art, and 2) coverage for property and liability. These are two totally different concepts. At a basic level, an institution, collector, artist, or gallery owner should have property and liability coverage. Fine arts coverage is often a luxury. The ever increasing value of art means people and institutions need to keep an eye on what is happening in the art market, and act accordingly. If prices are going way up, make sure that your policy provides enough coverage for your art. It is a lot of work. Many appraisers now offer frequent updates to schedules with new sophisticated computer programs. There is a lot to think about.

Thoughts on Experimental and Nontraditional Artists' Materials and Advice to Artists, Dealers, and Collectors on How to Assess and Preserve Such Materials

Albert Albano, Executive Director, Intermuseum Conservation Association

Q. Some critics claim that much of today's art will not stand the test of time, and some collectors are uncertain how to approach investing in art when the materials used are so experimental. As a conservator of painting with a specialty in modern and contemporary art you have examined and treated thousands of paintings, collaged artworks, and painted sculptures. Have you observed that the nontraditional and sometimes experimental media used by artists since the 1940s has had a noticeably detrimental effect on the stability and longevity of the artwork?

A. There is no question that the greater number of less traditional or disparate, new, and commercial materials used in creating a work of art, particularly when those materials are used in ways unintended by a manufacturer, increase the likelihood of problems for an artwork's long-term survival (I mean centuries, not a few decades), at least in the physical and visual state that the artist intended.

Q. How much does the physical change in an artwork matter in relation to the artist's intent? Can you give some specific examples of changes that you have observed in major artists' work that you felt were or were not important?

A. I think that the artist's original intent is at the very crux of the matter when you're talking about physical and associated visual alteration of a work of art. With some post-World War II artists, like Ad Reinhardt, Ellsworth Kelly, earlier Brice Marden, and Robert Ryman, for example, where visual intent exists successfully only within fairly narrow physical parameters, surface damages like abrasion, scuffs, or rubs can sometimes be fatal for the painting. In other instances, a good example being Anselm Kiefer, slight surface alteration really doesn't affect the artist's intentions for a successful interpretation of the painting.

In fact, to some degree, visual alteration associated with aging is an anticipated part of the creative process. These are some obvious extremes. Most artists' work falls between these extreme parameters, and damage or age alteration needs to be interpreted and judged individually in terms of the effects on the artists' visual intentions.

Q. How would you advise a collector to approach the purchase of an artwork done with nontraditional materials? Are there certain questions that the collector should be asking the artist to help him understand the best way to preserve his investment, or to understand how important possible future visible changes will be? Do you offer certain advice to dealers and collectors for how best to store or exhibit artwork done with experimental media?

A. You need to approach a potential acquisition objectively in terms of concerns for the artwork's physical survival in perpetuity. I would never advise a collector, for example, or institution, for

that matter, not to acquire an important work of art because of my professional concerns for its longevity, but I would feel responsible about informing all parties involved including the artist, if that were possible, about my prognosis for the potential longevity of the artwork in the state he or she intended, given my knowledge and experience of art, other materials and their use.

The more information a potential steward of a work of art can acquire before acquisition the better. This is beneficial for a number of reasons, some less obvious than others. Firstly, it can provide you with guidelines of when you should be concerned about an alteration and, perhaps, when you shouldn't. This is also helpful in determining when you should call in the appropriate conservator to have a look. Understanding a little something about the artist's process can also help mitigate a potential problem with expectation about the artwork's inevitable physical evolution over time. After all, artworks age just like people and deterioration is a natural consequence of aging. As I said earlier, it's how that aging affects the artwork's intended appearance and the degree to which that intended appearance may evolve with time that is the real issue.

I think it's a solid rule that the more stable the environment in which the artwork will live, the better. I think it is pretty sound advice that the more fragile or potentially unstable an artwork is the more important a stable environment will be to the long-term survival of the artwork in the way it's intended to look.

Q. Specifically, what can be done to preserve plastic and rubber materials that are inherently

unstable and will yellow, harden, split, or disinte-
grate over time? Does a collector have to be
prepared to replace these in the future, or can a
collector do something else to slow the progress
of the inherent problems?

A. Early plastics and other unusual synthetic
materials often have very physically unstable
lives, particularly as they age. There are a whole
list of do's and don'ts with these materials in
terms of helping them to survive longer in a state
most closely approximating their original fabrica-
tion appearance. In general, plastics should be
kept in a cool, dry, preferably dust free environ-
ment. Keeping the air fresh and circulating is
important to prevent the buildup of problematic,
off-gassed materials from catalyzing further or
more accelerated deterioration. Try to keep them
out of direct display light and even store them in
the dark when not on view, if possible. Try to
keep them off of and away from acidic materials
or other known problematic synthetics in their
storage or exhibition. Inspect the objects regularly
for signs of deterioration.

Some of the problems that have occurred with
early plastics used in art have become notorious
preservation stories, particularly the early cellu-
loid used by the Pevsner brothers, Maholy Nagy,
and others for purposes of visual transparency,
perceived dimensional stability, etc. Much of this
plastic material has shrunk, deformed, stress
cracked, and at the very least severely discolored
or self-destructed by shattering to pieces. On the
other hand, sulfur based natural rubbers and latex
will ultimately crack and crumble over time,
particularly in unfavorable environments. This is

also true for certain types of synthetic rubbers and foams as polyurethane foam.

Q. How do you advise artists when they call upon you to help them with problems that they are observing with their paintings, or that they worry might occur in the future because of non-orthodox materials or techniques they are using to achieve certain effects?

A. I think that there's a bit of a myth out there that contemporary artists don't care about materials, their use and longevity, but rather are only inter-ested in the immediate results. I know there are examples of artists who may feel this way, but from my experience this is by no means the norm. My own experience in general has been that contemporary artists are no less responsible about their work than artists of other centuries, and when things go wrong with a contemporary art-work it is more from a lack of information or access to it, or artists' materials manufacturers who do not make it easy for artists to understand the limitations or proper use of their materials. My first approach to these problems is to under-stand the visual effect the artists were trying to achieve, what materials they are using, and how they are using them to attain their desired effects. In some instances the results of a process are not strictly intended, but are an accepted or even satisfying consequence of a process. I try to offer an interpretative balance between the artist's visual intention and the possible physical conse-quence to his artwork, should there be any, that I can reasonably and responsibly predict. It is very rarely an either or situation such that either the

artist stops using a certain material or technique, or the artwork will self-destruct, to express it dramatically. Most of the time, if the artist wants to, we can come up with a perfectly acceptable modification of a technique or, in some cases, the substitution of a similar but perhaps higher quality, or more stable material to achieve a very similar or even the same result.

I believe it is my role to provide the information as best I can or to do the research where necessary concerning my understanding of the chemistry of materials and offer the information. It's a matter of interpreting the specs and the data on the materials and making the best predictions for the longevity of the artwork that I can responsibly make, and then letting the artist decide. I'm a very strong believer that it is not within the role of the conservator to enter the creative process of the artist any more than is necessary or appropriate. This can be hard for some conservators who have been trained to try to preserve cultural material in perpetuity, but the rules for some contemporary art can often push the parameters of this direction to the limits.

Q. At what point in a purchase should a collector consider seeking the advice of an art conservator to evaluate an artwork's condition?

A. It makes good sense to consult an appropriate conservator about the condition of a work of art before he or she gets too wedded to the idea of a purchase, particularly if there are any concerns about the condition or stability of the artwork. I'm not suggesting that this necessarily be the decisive factor for the purchase, but it's best for all in-

volved in the potential deal to feel they've got as much of the information in hand about the artwork as possible. This can prevent a costly mistake. At the very least, artists do not want people to talk negatively about the stability of their art, and will try to do what is best to accommodate a perennial problem if it exists.

Q. How can a collector know when an artwork has been over-restored, that it no longer reflects the artist's original intent and that the asking price is inappropriate based on the restoration?

A. Concerns about previously or over-restored contemporary artworks should again be referred to the appropriate conservator. In some cases, depending on the situation and the significance of the artwork, the purchase may very likely still go forward, but perhaps at some appropriate percentage reduction in the price. In some cases there may be a significant depreciation in the value of the work and it might be best to wait for another piece in better condition. In conclusion, I would like to add that the idea of an artwork remaining eternally in perfect, unaltered condition is a bit delusional and to remind you that again the real formula should be how significant is the alteration, whether it be from age or from a conservation procedure that changed the original intent of the artwork.

Q. Could you briefly explain how poor handling of paintings by artists, dealers, art handlers, or collectors can permanently damage a painting?
A. I find that those who handle artwork regularly sometimes do so in a manner so casual that they

may have to be reminded to approach the art with the degree of care and responsibility commensurate with the respect they see and hear me handle and discuss this subject with them. The point is that thinking through the handling process in advance can often avoid very costly and sometimes permanent damage to an artwork. It's almost always cheaper to go the extra mile in terms of appropriate packing and shipping, for instance, than it is to deal with the consequences and cost of correcting the damage to the artwork.

Q. Could you discuss the pros and cons of rolling paintings, which often has to be done today with very large works of art when they are stored or transported?

A. Frequently, rolling a large painting is the only feasible method of transportation. There are a number of appropriate variations when a painting is to be rolled, but two unalterable rules are to use the widest tube possible, eighteen inches or wider is not uncommon, and preferably nothing narrower than twelve inches in diameter. The other is to roll the painting face out using an appropriate interleaving material to properly isolate the painted surface. A frequently used interleaving material is glassine, although there are other alternatives depending on the nature of the paint's surface.

Photographs and Computer-Generated Images

Andrew Robb, Photograph Conservator

Q. Could you give a brief overview of the stability of the different photographic materials being used by contemporary artists and what factors influence their longevity? As I recall the original text of this book did not mention photographs or computer-generated images, and I am not sure whether digital photographs or so called Iris prints had even been conceived at the time of publishing.

A. Most monochromatic photographs, commonly known as black-and-white photographs, are made with various forms of silver and are sometimes toned with other metals such as selenium, sulfur, or gold. The gelatin silver photograph, which is made of silver in a layer of gelatin with a subbing layer of baryta between the gelatin and the paper, is the most common form of monochromatic photograph in contemporary work. Compared to color images, silver gelatin photographs are quite stable. They can, however, deteriorate from high levels of relative humidity, temperature, pollutants, and light. Evidence of deterioration includes image mirroring, yellowing, and fading. Some monochromatic photographs are made of palladium or platinum, which do not have a binder or a subbing layer. These metals are more stable than silver and photographs made from them can be very permanent.

Virtually all the color photographs produced today use dyes to form the image. Unlike inorganic pigments that are quite stable, dyes are organic compounds, which are sensitive to tem-

perature, relative humidity, light, and pollutants. Chromogenic dye photographs, which include color prints, negatives, and slides are the most common color processes. These are the photographs that you can have done at your neighborhood drug store. Film with C-41, E-6, and K-14 are examples of this process. Chromogenic dyes, especially those from before the late 1980s, are particularly sensitive to high levels of humidity and temperature. The purplish cast and yellowish staining often seen in such photographs are signs of deterioration from high humidity and temperature. This type of damage, known as dark fading, can occur even without the presence of light. Chromogenic dyes are also light-sensitive and fade typically by taking on a cyan (blue) cast from light exposure. Dyes used in dye diffusion transfer photographs (also known as Instant, One-Step, or Polaroid) are fairly stable, but their complex, physical structure makes them vulnerable. Recommendations for the longevity of these products are similar to those recommended for chromogenic color. Silver dye bleach photographs (also known as Cibachrome and Ilfochrome) use azo dyes, which are more stable to dark fading than chromogenic dyes, and these photographs will remain unchanged for many, many decades, if placed in good storage conditions. Silver dye bleach photographs are sensitive to light fading and should not be left on permanent display.

Since chromogenic dyes are vulnerable to fading because of temperature and relative humidity even at ideal conditions of 68° F and 45 percent relative humidity, many institutions, some artists, and collectors place their color photographs in cool to cold conditions. Cold storage

should be done carefully. Henry Wilhelm's book *The Permanence and Care of Color Photographs* and the Image Permanence Institute's *Storage Guide for Color Photographic Materials* and *Storage Guide for Acetate Film* are good if you want to learn more about film-based materials, color photographs, and cold storage.

A permanent display of photographs is not recommended. Artists and collectors should take what measures they can to keep light levels on their pieces as low as possible, especially when the photographs are not on view. Small institutions should follow established, museum-lighting guidelines during temporary exhibition of photographs.

Q. I hear that some problems have been observed with silver gelatin prints on resin-coated, rather than fiber-based paper, particularly minute fracturing of the resin coating and discoloration. Why does this occur?

A. As mentioned before, silver is vulnerable to deterioration, which is caused by the environment. The reasons for the change in black-and-white silver photographs on resin-coated paper are topics of some debate. Many believe that very, very small amounts of contaminants in the resin-coated paper cause the change, as well as other such factors as environment and poor framing materials. While fiber-based silver gelatin prints use barium sulfate as the subbing layer between the paper and gelatin emulsion, resin-coated photographs use titanium dioxide. The titanium dioxide can oxidize in the presence of ultraviolet radiation, which in turn can lead to the oxidation and ultimate discoloration of the silver in the

resin-coated photographs. Because testing results have been unpredictable, some believe that environmental pollutants alone, and not the resin-coated paper, cause the changes. Unfortunately at this time we have no clear answer to the problem.

Q. Which photographic process for black-and-white negatives and prints, slides, or color transparencies do you recommend for artists, collectors, and small institutions to use when documenting their works of art?

A. A well-processed, silver gelatin photograph on fiber-based paper can last for a very long time (many centuries) when stored under the proper conditions. We know this not only from testing, but also from looking at early silver photographs that are still in good condition from the 1840s. If you are looking for permanence and well-understood, mature technology, and if a monochromatic image suits your need, silver gelatin photographs are very good.

For many, however, color is critical and using some type of color photography or imaging is necessary. Transparency film captures a wider range of tones than color negative film and is commonly used to document artworks. Many people ask, "Should I use Kodachrome or Ektachrome film for my slides?" Kodachrome, a K-14 film, is a unique Eastman Kodak product. Ektachrome, Eastman Kodak's trade name, is an E-6 film and a number of other companies make the same film, such as Fuji's Fujichrome and Agfa's Agfachrome. While both these slides films are chromogenic, they use different dye sets, and have somewhat different stabilities. Until 1988,

Kodachrome had better dark fading stability than Ektachrome, while Ektachrome had better light stability. At that time, the recommendation was to use Kodachrome for long term keeping and Ektachrome for slide projection. Recent improvement in the dye stability of Ektachrome type E-6 film has made it as dark stable as Kodachrome. Because of the new stability and convenience of this type of film (Ektachrome is cheaper and easier to process than Kodachrome), many people now use Ektachrome film for documentation. Whichever you choose for your documentation, buy a brand name film, not a cheaper 'store brand' and be certain that your film has not expired.

Q. Is taking a digital image and storing it on a compact disc a difficult or viable option for documentation?

A. To store your digital files, recordable compact discs (CD-R's) are not a bad choice, but you need to consider their advantages and disadvantages. Recordable compact discs use organic dyes to record the binary information of a digital image file. While the dyes used are quite stable, they are not impervious to environmental threats. Most indications are that dye-based images last about fifty years, which is better than magnetic tape that has a life span of fifteen to twenty years. The dyes used on these discs do vary and a cheap disc may not be the best choice in the long run. A good Web site for information on CD-R's is www.cdmediaworld.com/hardware/cdrom/ cd_quality.html. Scratches and mishandling damage discs quite easily. Machine obsolescence is the most likely future problem with CD-R's. While

the disc may survive for many decades you may have trouble finding a machine to read it. Migration of digital files to new and different media is something that you should plan to do if you are concerned about the longevity of your artwork or documentation.

Q. I keep hearing from what you are saying that photographs are probably more sensitive than most other artwork. It is very clear that good framing, storage, and exhibition methods are critical for the longevity of most modern photographic material. Many people may not realize that special papers and boards have been developed specifically for the storage and exhibition of photographs. These papers and boards are subjected to a test called the Photographic Activity Test (PAT) before they can be labeled as safe for contact with photographs. Could you briefly explain how these materials for photographs differ from other archival paper products?

A. Poor-quality storage enclosures can contain a variety of harmful components including oxidants, acids, and sulfur. In addition to causing chemical degradation of photographs stored within enclosures, these components tend to degrade the enclosures themselves, which provides the photograph with less and less physical protection. Fortunately, a test exists for evaluating the materials used to make paper enclosures. The Photographic Activity Test is described in a standard written by the American National Standard Institute (ANSI IT9.16-1993). This standard provides a way for buyers of enclosure materials to know that what they buy will not harm their photographs.

Many manufacturers and suppliers of housing materials now conduct this test on their products. If at all possible, purchase products that have passed the Photography Activity Test.

This stringent test determines whether an enclosure will cause fading or staining in a photograph that has a silver image and a gelatin binder. A variation of the test also exists for chromogenic color photographs. While not all photographs contain both silver and gelatin, the PAT provides a good way to determine if an enclosure contains harmful components. It is better to use a poor quality enclosure than not use one at all. Even an enclosure of poor quality material provides some degree of physical protection from damage from handling. Most high quality papers pass the PAT. Some, however, will not pass because of sizing, or a paper might react adversely to bleaches, surface coatings and other additives. It is better to use an untested paper than to leave your photos unprotected. If a decision must be made between using an old groundwood enclosure or a new high quality paper enclosure without available PAT data, the high quality paper should be used. As with the environment, incremental improvements in storage enclosures are beneficial.

The PAT standard also describes other criteria that an enclosure should meet, such as strength and surface quality, and it makes general recommendations about the use of plastics for storing photographs.

Q. Most plastic storage materials cause severe damage to photographs. This might include yellowing, softening of the gelatin, and actual irreparable sticking to the surface of a negative or print.

What are the plastic materials that should be allowed in contact with photographic negatives and prints?

A. Many plastics contain coatings, plasticizers, and other additives which can harm photographs. Polyester, polypropylene, and polyethylene are the recommended types of plastic for photographic enclosures because they are chemically inert. Many suppliers use these plastics for their enclosures. Other plastics, especially polyvinyl chloride (PVC), should be avoided; these other products are unstable, and as they deteriorate they emit harmful degradation products. The main advantage of using plastic enclosures is that they are transparent and photographs can be viewed easily, greatly reducing handling damage.

Some caution should be used when purchasing enclosures made of polyester, polypropylene, and polyethylene. Static buildup is a problem with polyester sheeting, which can cause damage with photographs that flake or have loosely bound, applied color. "Matte" polyester should also be avoided, because this polyester's rough surface can damage the surface of a photograph. Thin sheets of polyethylene should be avoided because they are very prone to sticking. The main disadvantage of plastic enclosures is that a photograph can stick to plastic at a relative humidity above 70 percent; therefore, plastic enclosures should be used only if relative humidity is kept below 70 percent relative humidity.

Q. In spite of rapid changes in the technology, can you discuss longevity and stability issues for art works, and advise artists which products to choose

if they want to preserve their work?

A. Inks used in printers are made in two ways—with pigments and with azo dyes. Pigments are increasingly being used, but dyes are still the most common colorant. As described earlier, light fading of dyes can be a problem. Unfortunately there is no easy way to tell if an ink set uses pigments or dyes. Unless the manufacturer indicates that it uses pigments, you should assume a dye is being used as the colorant.

If you have questions about the longevity of your digital output there is a way to test for lightfastness, based on ASTM D 5398 Standard Practice for the Visual Determination of the Lightfastness of Art Materials by the User. This standard describes a way to make samples of your work by 1) covering half, 2) dating your test sample, and 3) placing it in a sunny window. Over time you can compare the covered area with the exposed area to see if fading or staining has occurred with the materials you used in your artwork. This is very important because light-fading sensitivity of the same dye set changes, depending upon the other materials in the artwork, such as paper and coatings. Henry Wilhelm has shown that the same ink set printed by the same printer on different supports can result in very different light stabilities. This ink-and-support interaction demonstrates the importance of knowing as much as possible about the specific ink set-and-paper combination, not only when making prints, but also when buying them.

Moisture sensitivity is another area of concern at this time. Within the ink jet process, many, if not most, prints have been found to be sensitive to

water and smudges. Image loss can result from a brief encounter with water over short time periods. This is a physical problem. Unlike dye fading, moisture does not cause a change in chemical composition resulting in a change in appearance. Instead, the dye is solubilized and moves on and into the support surface. This physical change is irreversible and cannot be treated. Coatings may be applied to a print to decrease sensitivity to moisture, but at this time, coatings only reduce the risk of moisture damage and do not eliminate it. Pigment systems are much less sensitive to moisture.

Digital images, especially early ones, can also be very sensitive to light exposure. New pigment-based digital printers may prove to be quite stable upon prolonged exposure, but they remain fairly new. Proceed with some caution with these new materials.

Q. Should a collector or collecting institution insist upon knowing the materials used before buying an Iris print?

A. Absolutely. Getting as much information as you can helps you to understand what you are buying and how vulnerable the materials used are to light fading and other deterioration.

Q. How should a collector assess the stability of an Iris print if he has been given no information on its production process?

A. The earlier the print was made the more I would be careful in its display. Wilhelm's Web site has a wealth of information about the im-

provements in lightfastness over the past decade. With this information you can at least have a rough idea of the sensitivity of the object you have.

Q. Is there a good public or private source of information, published or on the Web, about the changes in the field of print production technology that an artist should be consulting to keep abreast of this fast changing industry?

A. The best non-industry Web sites are Wilhelm Research (http://wilhelmresearch.com/), which gives a great deal of information about the testing on different ink sets, and the Image Permanence Institute (www.rit.edu/~661www1/), which gives useful links to other sites in this new field. These are excellent places to keep abreast of what is going on in this rapidly changing technology arena.

Q. I know there are fine catalogs and specialty books in the bibliography of *Caring for Your Art* that explain the different methods for storing and exhibiting negatives and photographs, but can you give one overriding recommendation for maintaining longevity of photographs and digital images?

A. The most important things you can do in caring for your photographic or digital image, are 1) to keep it in a cool, dry environment and 2) to limit light exposure. Imaging materials are sensitive to the environment in varying degrees and benefit greatly from good care. A typical, recommended environment for your photographic images that

people can also tolerate is 68°F and 40 percent relative humidity. Although all this may not be possible, it is important to realize that incremental improvements in storage conditions are still beneficial. For every 10° degree decrease in temperature, the life span of your image is increased, even doubled. This is also true for every 20 percent decrease in relative humidity. Basically, store your images (at least your most important ones) where you are comfortable, and not in a hot attic or a musty, damp basement. Buy an air conditioner if you don't already have one! Go for cold storage, even a frost-free refrigerator, if you have the space, money, and inclination to learn how to prepare and remove items from the cold.

BIOGRAPHIES

Albert Paul Albano, specialist in modern and contemporary art conservation, is Executive Director of the Intermuseum Conservation Association, a not-for-profit art conservation and preservation organization. He is former Director of Conservation at the Winterthur Museum and Gardens, Winterthur, Delaware, and Senior Conservator at the Museum of Modern Art, New York.

Eric Fischer is Vice President at Fine Arts Risk Management, Washington, DC, and has worked for over ten years with museums, collectors, and galleries in America and abroad, advising on insurance and covering some of the largest exhibitions ever assembled.

Barbara Appelbaum and **Paul Himmelstein** have worked together in a New York City private practice since 1972, providing conservation treatments on a variety of paintings and objects and consulting on collections care for museums, historical societies, and private owners. Appelbaum is a past vice president of the American Institute for Conservation (AIC) and Himmelstein is a past president of AIC.

Andrew Robb, photographer conservator, has been a consultant and contract conservator for a number of institutions, including the Smithsonian Institution, the National Gallery of Art, and the Library of Congress.

Mervin Richard is Deputy Chief of Conservation at the National Gallery of Art, Washington, where he has worked since 1984. Mr. Richard served as Co-chairman of the ICOM Working Group for Preventive Conservation and the ICOM Working Group for Works of Art in Transit.

Ann Craddock Albano is Registrar at the Cleveland Center for Contemporary Art and a paper conservator. She is former Director of Paper Conservation at the National Museum of American History and Assistant Paper Conservator at the Museum of Modern Art, New York. She has published on environmental issues in museums and case construction materials

SELECTED BIBLIOGRAPHY

FINE ARTS INSURANCE

A.M. Best Company. *Best's Insurance Reports, Property-Casualty.* Oldwick, NJ: A.M. Best Company, 1989.

Castle, G., R. Cushman, and P. Kensicki, eds. *The Business Insurance Handbook.* Illinois: Dow Jones-Irwin, 1981.

Chapman, T.S., M.L. Lai, and E.E. Steinbock. *Am I covered for...? A Guide to Insurance for Non-Profits.* Philadelphia: Insurance Company of North America/Aetna Insurance Company, and CIGNA Companies, 1984.

Chemick, V.P. *The Consumer's Guide to Insurance Buying.* Los Angeles: Sherbourne Press, n.d..

The Chronicle of Philanthropy (April 18, 1989). Article and recommendations on insurance needs for nonprofit organizations by the Nonprofit Sector Risk and Insurance Task Force.

Davids, L.E. *Dictionary of Insurance* (Sixth Revised Edition). Totowa, NJ: Ron & Allanheld, 1984.

Keeton, R.E, and A.K. Widiss. *Insurance Law: A Guide to Fundamental Principles, Legal Doctrines and Commercial Practices* (Student Edition). St. Paul, MN: West Publishing, 1988.

National Underwriter Company Reference Book Department. *Who Writes What.* Cincinnati, OH: National Underwriter Company, 1973.

Texas Accountants and Lawyers for the Arts. *Insurance-A User-Friendly Guide for the Arts and Non-Profit World.* Houston: Browne, n.d.

PHOTOGRAPHS AND DIGITAL IMAGES

Reilly, James. *IPI Storage Guide for Acetate Film.* Rochester, NY: Image Permanence Institute, Rochester Institute of Technology, 1993. [also available in electronic format at www.rit.edu/~661www1/]

Storage Guide for Color Photographic Materials. Albany, NY: University of the State of New York, New York State Education Department, New York State Library, the New York State Program for the Conservation and Preservation of Library Research Materials, 1998.

Wilhelm, Henry. *The Permanence and Care of Color Photographs: Traditional and Digital Color Prints, Color Negatives, Slides, and Motion Pictures.* Grinnell, Iowa: Preservation Company, 1993. [additional information for digital output at www.wilhelm-research.com]

ENVIRONMENT AND STORAGE

Thomson, Garry. *The Museum Environment.* Oxford: Butterworth-Heinemann, 1994.

Appelbaum, Barbara. *Guide to Environmental Protection of Collections.* Madison, CT: Sound View Press, 1991.

The National Committee to Save America's Cultural Collections. *Caring For Your Collections.* New York: Harry N. Abrams, Inc., 1992.

Bachmann, Konstanze. *Conservation Concerns: A Guide for Collectors and Curators.* Washington: Smithsonian Institution Press, 1992.

EXPERIMENTAL AND NON-TRADITIONAL ARTISTS MATERIALS

Price, Nicholas S., M. Kirby Talley, Jr., and Alessandro Melucco Vaccaro, eds. *Historical and Philosophical Issues in the Conservation of Cultural Heritage.* Los Angeles: The Getty Conservation Institute, 1996.

SOURCES OF SUPPLIES and SERVICES

Light Impressions
P.O. Box 22708
Rochester, NY 14692-2708
800.828.6216
www.lightimpessionsdirect.com
Specialty is photographic materials

Nouvir (Fiber-optic lighting company)
20915 Sussex Highway
Seaford, DE 19973
302.628.9933

University Products
517 Main Street
P.O. Box 101
Holyoke, MA 01041-0101
800.628.1912
www.universityproducts.com
Use their catalog Archival Quality Materials for Conservation, Restoration, and Preservation. They offer, at no fee, consultation with a trained conservator.

Conservation Resources International, L.L.C.
8000-H Forbes place
Springfield, VA 22151
800.634.6932
www.conservationresources.com

Gaylord Bros.
P.O. Box 4901
Syracuse, NY 13221-4901
800.448.6160
www.gaylord.com/archival
Use their catalog Archival, Your Preservation Resource Guide

The Hollinger Corporation
P.O. Box 8360
Fredericksburg, VA 22404
800.634.0491
www.hollingercorp.com

Talas
568 Broadway
New York, NY 10012
212.219.0735

Conservator Emporium
100 Standing Rock Circle
Reno, NV 89511
775.852.0404
www.consemp.com

CHOOSING A CONSERVATOR

American Institute for Conservation of Historic
and Artistic Works (AIC)
1717 K Street, NW
Suite 301
Washington, DC 20006
202.452.9545
http://aic.stanford.edu
Can provide lists of conservators and provides
the publication:
American Institute for Conservation of Historic
and Artistic Works and the Foundation of the
AIC. *Guidelines for Selecting a Conservator.* 3rd
ed. Washington: AIC/FAIC, 1987.

SOURCES OF TECHNICAL PUBLICATIONS

American Association of Museums
Bookstore Catalogue
1575 Eye St., NW
Washington, DC 20005
202.289.9127
www.aam-us.org

ArtByte (magazine)
www.eapgroup.com/artbyte.htm
Website description: ArtByte is focused on global developments in digital arts and on studies, discoveries and innovation in the applications of computer technologies towards the conservation of art and reinterpretations of art history.

Canadian Heritage Information Network
800.520.2446
www.chin.gc.ca

INDEX

INDEX

Allworth Books

An Artist's Guide: Making It in New York City
by *Daniel Grant* (paperback, 6 x 9, 256 pages, $18.95)

The Business of Being an Artist, Third Edition
by *Daniel Grant* (paperback, 6 x 9, 352 pages, $19.95)

The Artist-Gallery Partnership:
A Practical Guide to Consigning Art, Revised Edition
by *Tad Crawford* and *Susan Mellon* (paperback, 6 x 9, 216 pages, $16.95)

Legal Guide for the Visual Artist, Fourth Edition
by *Tad Crawford* (paperback, 8 1/2 x 11, 272 pages, $19.95)

The Law (in Plain English) for Galleries, Revised Edition
by *Leonard DuBoff* (paperback, 6 x 9, 208 pages, $18.95)

The Artist's Complete Health and Safety Guide
by *Monona Rossol* (paperback, 6 x 9, 408 pages, $24.95)

Artists Communities: A Directory of Residencies in the United States That Offer Time and Space for Creativity, Second Edition
by the *Alliance of Artists' Communities* (paperback, 6 3/4 x 9 7/8, 256 pages, $18.95)

Corporate Art Consulting
by *Susan Abbott* (paperback, 11 x 81/2, 256 pages, $34.95)

Fine Art Publicity
by *Susan Abbott* and *Barbara Webb* (paperback, 8 1/2 x 11, 190 pages, $22.95)

The Artist's Guide to New Markets:
Opportunities to Show and Sell Art Beyond Galleries
by *Peggy Hadden* (paperback, 5 1/2 x 8 1/2, 252 pages, $18.95)

The Fine Artist's Guide to Marketing and Self-Promotion
by *Julius Vitali* (paperback, 6 x 9, 224 pages, $18.95)

The Fine Artist's Career Guide
by *Daniel Grant* (paperback, 6 x 9, 224 pages, $18.95)

Business and Legal Forms for Fine Artists, Revised Edition with CD-ROM
by *Tad Crawford* (paperback, 8 1/2 x 11, 144 pages, $19.95)

The Artist's Resource Handbook, Revised Edition
by Daniel Grant (paperback, 6 x 9, 248 pages, $18.95)

Please write to request our free catalog. To order by credit card, call 1-800-491-2808 or send a check or money order to Allworth Press, 10 East 23rd Street, Suite 510, New York, NY 10010. Include $5 for shipping and handling for the first book ordered and $1 for each additional book. Ten dollars plus $1 for each additional book if ordering from Canada. New York State residents must add sales tax.

To see our complete catalog online, or to place an order, go to: **www.allworth.com**